Gothic Architecture and Scholasticism

Gothic Architecture and Scholasticism

by *Erwin Panofsky*

A MERIDIAN BOOK

MERIDIAN
Published by the Penguin Group
Penguin Books USA Inc., 375 Hudson Street,
New York, New York 10014, U.S.A.
Penguin Books Ltd, 27 Wrights Lane,
London W8 5TZ, England
Penguin Books Australia Ltd, Ringwood,
Victoria, Australia
Penguin Books Canada Ltd, 10 Alcorn Avenue,
Toronto, Ontario, Canada M4V 3B2
Penguin Books (N.Z.) Ltd, 182–190 Wairau Road,
Auckland 10, New Zealand

Penguin Books Ltd, Registered Offices:
Harmondsworth, Middlesex, England

Published by Meridian, an imprint of New American Library, a division of
Penguin Books USA Inc.

First Printing/Work Publishing Company, 1957
First Printing/New American Library, March, 1976
19 18 17 16 15 14 13 12 11

 REGISTERED TRADEMARK—MARCA REGISTRADA

LIBRARY OF CONGRESS CATALOG CARD NUMBER: 57-6681
Printed in the United States of America

Foreword

PROFESSOR Erwin Panofsky's study, *Gothic Architecture and Scholasticism,* captured and holds an eminent place in a series that is not without distinction, the Wimmer Lectures. Established in memory of the founder of the Benedictine Order in America, Boniface Wimmer, the series has brought to St. Vincent College such fine scholars as Jacques Maritain (Man's Approach to God"), William F. Albright ("Toward a Theistic Humanism"), Helen C. White ("Prayer and Poetry"), and Elias A. Lowe ("The Finest Book in the World").

Boniface Wimmer would surely have approved the matter and the manner of this lecture. In a letter written nearly a hundred years ago he said:

> In a country like America . . . religion and art must work together to give our liturgy an outward splendor, great dignity, and even grandeur. . . . Therefore the monasteries have a solemn duty to foster art, especially religious art, to improve it and to spread it, because our shopkeepers and our farmers will never do that. I am firmly

> convinced that a monastic school which does not strive to
> advance art as much as science and religion will be de-
> ficient in its work. In scientific matters shortcomings may
> be more readily condoned, at least in the beginning, but
> neglect in the promotion of art must be censured.

Nine decades have not diminished the force of these
words.

Professor Panofsky represents that firm, mature,
and humane learning that is the ideal and the despair
of so many. Since 1935 he has been associated with
the School of Humanistic Studies at The Institute for
Advanced Study, Princeton, New Jersey. His career
before that took him from his native Hanover to the
universities of Berlin, Munich, Freiburg, and Ham-
burg. An authority on iconology, medieval, renaissance,
and baroque art, and Dutch and Flemish book illumi-
nation, he has been a lecturer or professor at various
universities in the United States.

Knowledge as comprehensive in its grasp and diver-
sification as it is precise and sure in detail, brilliant
insight and penetrating analysis, stimulating, radiant,

and artistic presentation—these are qualities it is customary to take for granted in a study by Professor Panofsky. It is a source of satisfaction to see his provocative lecture made available to a wider public through Meridian Books. Extremely heavy demands upon Professor Panofsky's time have prevented him from introducing into the text revisions he would now consider desirable. We do not hesitate to issue the text in its original form, quite willing to let it stand on its own merits.

✝ QUENTIN L. SCHAUT, O.S.B.

List of Illustrations

Figure 1.
Tombstone of the Architect Hugues Libergier (died 1263), Reims Cathedral.

Figure 2.
Autun Cathedral, west portal. *Ca.* 1130.

Figure 3.
Paris, Notre-Dame, central portal of the west façade (much restored). *Ca.* 1215–1220.

Figure 4.
Henry I of France bestowing privileges upon the Priory of St.-Martin-des-Champs. Book illumination between 1079 and 1096, London, British Museum, ms. Add. 1162, fol. 4.

Figure 5.
Henry I of France bestowing privileges upon the Priory of St.-Martin-des-Champs. Book illumination of *ca.* 1250, Paris, Bibliothèque Nationale, ms. Nouv. Acq. lat. 1359, fol. 1.

Figure 6.
Philip I of France bestowing privileges upon the Priory of St.-Martin-des-Champs. Book illumination between

Illustrations

Illustrations

Figure 24.

Soissons Cathedral, vaults of the southern side aisle in course of restoration after World War I. Beginning of the XIIIth century.

Figure 25.

Soissons Cathedral, section of the northern nave wall damaged during World War I. Beginning of the XIIIth century.

Figure 26.

Chartres Cathedral, flying buttress of the nave. Design established shortly after 1194.

Figure 27.

Reims Cathedral, Madonna in the right hand portal of the northern transept. *Ca.* 1211–1212.

Figure 28.

Durham Cathedral, concealed flying buttresses. End of the XIth century. (After R. W. Billings, *Architectural Illustrations and Description of the Cathedral Church of Durham*, London, 1843.)

Figure 29.

Reims Cathedral, open flying buttresses of the nave. Design established *ca.* 1211.

Figure 30.

St.-Denis, west façade. Dedicated 1140. (After an en-

Illustrations

graving by A. and E. Rouargue, executed before the restoration of 1833–1837.)

Illustrations

Illustrations

Illustrations

Figure 55.

Chartres Cathedral, capital of pier. Design established shortly after 1194 (diagram).

Figure 56.

Reims Cathedral, capital of pier. Design established *ca.* 1211 (diagram).

Figure 57.

Amiens Cathedral, capital of pier. Design established *ca.* 1220 (diagram).

Figure 58.

Beauvais Cathedral, capital of pier. Design established *ca.* 1247 (diagram).

Figure 59.

St.-Denis, capital of pier. Design established *ca.* 1231 (diagram).

Figure 60.

Villard de Honnecourt, ideal groundplan of a chevet resulting from his discussion with Pierre de Corbie. Drawing of *ca.* 1235, Paris, Bibliothèque Nationale.

Gothic Architecture and Scholasticism

THE HISTORIAN CANNOT HELP DIVIDING this material into "periods," nicely defined in the *Oxford Dictionary* as "distinguishable portions of history." To be distinguishable, each of these portions has to have a certain unity; and if the historian wishes to verify this unity instead of merely presupposing it, he must needs try to discover intrinsic analogies between such overtly disparate phenomena as the arts, literature, philosophy, social and political currents, religious movements, etc. This effort, laudable and even indispensable in itself, has led to a pursuit of "parallels" the hazards of which are

1

only too obvious. No man can master more than one fairly limited field; every man has to rely on incomplete and often secondary information whenever he ventures *ultra crepidam*. Few men can resist the temptation of either ignoring or slightly deflecting such lines as refuse to run parallel, and even a genuine parallelism does not make us really happy if we cannot imagine how it came about. Small wonder, then, that another diffident attempt at correlating Gothic architecture and Scholasticism[1] is bound to be looked upon with suspicion by both historians of art and historians of philosophy.

Yet, setting aside for the moment all intrinsic analogies, there exists between Gothic architecture and Scholasticism a palpable and hardly accidental concurrence in the purely factual domain of time and place—a concurrence so inescapable that the historians of mediaeval philosophy, uninfluenced by ulterior considerations, have been led to period-

2

ize their material in precisely the same way as do the art historians theirs.

I

To the Carolingian revival of the arts there corresponds, in philosophy, the phenomenon of John the Scot (*ca*. 810–877), equally magnificent, equally unexpected, and equally charged with potentialities not to be realized until a much later date. About a hundred years of fermentation in both fields were followed, in art, by the variety and contrariety of Romanesque which ranges from the planar simplicity of the Hirsau school and the severe structuralism of Normandy and England to the rich proto classicism of southern France and Italy; and, in theology and philosophy, by a similar multiplicity of divergent currents, from uncompromising fideism (Peter Damian, Manegold of Lautenbach and, ultimately, St. Bernard) and ruthless rational-

3

ism (Berenger of Tours, Roscellinus) to the proto-
humanism of Hildebert of Lavardin, Marbod of
Rennes and the school of Chartres.

Lanfranc and Anselm of Bec (the former died in
1089, the latter in 1109) made a heroic attempt to
settle the conflict between reason and faith before
the principles of such a settlement had been ex-
plored and formulated. This exploration and formu-
lation was initiated by Gilbert de la Porrée (died
1154) and Abelard (died 1142). Thus Early Scho-
lasticism was born at the same moment and in the
same environment in which Early Gothic architec-
ture was born in Suger's Saint-Denis. For both
the new style of thinking and the new style of build-
ing (*opus Francigenum*)—though brought about by
"many masters from different nations," as Suger
said of his artisans, and soon developing into truly
international movements—spread from an area com-

prised within a circle drawn around Paris with a radius of less than a hundred miles. And they continued to be centered in this area for about one century and a half.

Here High Scholasticism is generally assumed to begin with the turn of the twelfth century, precisely when the High Gothic system achieved its first triumphs in Chartres and Soissons; and here a "classic" or climactic phase was reached in both fields during the reign of St. Louis (1226–1270). It was in this period that there flourished such High Scholastic philosophers as Alexander of Hales, Albert the Great, William of Auvergne, St. Bonaventure, and St. Thomas Aquinas and such High Gothic architects as Jean le Loup, Jean d'Orbais, Robert de Luzarches, Jean de Chelles, Hugues Libergier, and Pierre de Montereau; and the distinctive features of High—as opposed to Early—

Scholasticism are remarkably analogous to those which characterize High—as opposed to Early—Gothic art.

It has justly been remarked that the gentle animation that distinguishes the Early Gothic figures in the west façade of Chartres from their Romanesque predecessors reflects the renewal of an interest in psychology which had been dormant for several centuries;[2] but this psychology was still based upon the Biblical—and Augustinian—dichotomy between the "breath of life" and the "dust of the ground." The infinitely more lifelike—though not, as yet, portraitlike—High Gothic statues of Reims and Amiens, Strassburg and Naumburg and the natural—though not, as yet, naturalistic—fauna and flora of High Gothic ornament proclaim the victory of Aristotelianism. The human soul, though recognized as immortal, was now held to be the organizing and unifying principle of the body

And Scholasticism

itself rather than a substance independent thereof. A plant was thought to exist as a plant and not as the copy of the idea of a plant. The existence of God was believed to be demonstrable from His creation rather than *a priori*.[3]

In formal organization, too, the High Scholastic *Summa* differs from the less comprehensive, less strictly organized, and much less uniform encyclopedias and *Libri Sententiarum* of the eleventh and twelfth centuries much in the same way as does the High Gothic style from its ancestry. In fact, the very word *summa* (first used as a book title by the jurists) did not change its meaning from a "brief compendium" (*singulorum brevis comprehensio* or *compendiosa collectio*, as Robert of Melun defined it in 1150) to a presentation both exhaustive and systematic, from "summary" to *summa* as we know it, until the final lustra of the twelfth century.[4] The earliest fully developed specimen of this new kind,

the *Summa Theologiae* by Alexander of Hales, which, according to Roger Bacon, ''weighed about as much as one horse can carry,'' was begun in 1231, the very year in which Pierre de Montereau began the new nave of St.-Denis.

The fifty or sixty years after the death of Saint Louis in 1270 (or, if we prefer, that of St. Bonaventure and St. Thomas in 1274) mark what is called the end phase of High Scholasticism by the historians of philosophy, and the end phase of High Gothic by the historians of art—phases in which the various developments, however important, do not as yet add up to a fundamental change in attitude but rather manifest themselves in a gradual decomposition of the existing system. Both in intellectual and in artistic life—including music, which from about 1170 had been dominated by the school of Notre-Dame in Paris—we can observe a growing trend towards decentralization. The cre-

8

ative impulses tended to shift from what had been the center to what had been the periphery: to South France, to Italy, to the Germanic countries, and to England, which, in the thirteenth century had shown a tendency toward splendid isolation.[5]

A decrease of confidence in the supremely synthetic power of reason which had triumphed in Thomas Aquinas may be discerned, and this resulted in a resurgence—on an entirely different level, to be sure—of currents suppressed during the "classic" phase. The *Summa* was again displaced by less systematic and ambitious types of presentation. Pre-Scholastic Augustinianism (asserting, among other things, the independence of the will from the intellect) was vigorously revived in opposition to Thomas, and Thomas's anti-Augustinian tenets were solemnly condemned three years after his death. Similarly, the "classic" cathedral type was abandoned in favor of other, less perfectly sys-

tematized and often somewhat archaic solutions; and in the plastic arts we can observe the revival of a pre-Gothic tendency toward the abstract and the linear.

The doctrines of "classic" High Scholasticism either stiffened into school traditions, or were subjected to vulgarization in popular treatises such as the *Somme-le-Roy* (1279) and the *Tesoretto* by Brunetto Latini, or were elaborated and subtilized to the limits of human capacity (not without reason does the greatest representative of this period, Duns Scotus, who died in 1308, bear the agnomen *Doctor Subtilis*). Similarly, "classic" High Gothic either became doctrinaire, to use Dehio's phrase, or was reduced and simplified (especially in the mendicant orders), or was refined and complicated into the harpwork of Strassburg, the embroidery of Freiburg, and the flowing tracery of Hawton or Lincoln. But it was not until the end of this period

that a basic change announced itself; and it was not until the middle of the fourteenth century—in histories of philosophy the conventional date for the shift from High to Late Scholasticism is 1340, when the teachings of William of Ockham had made so much headway that they had to be condemned—that this change became thoroughly and universally effective.

By this time the energies of High Scholasticism—setting aside the ossified schools of Thomists and Scotists that persisted much as academic painting survived and survives after Manet—had either been channelled into poetry and, ultimately, humanism through Guido Cavalcanti, Dante, and Petrarch; or into anti-rational mysticism through Master Eckhart and his followers. And insofar as philosophy remained Scholasticism in the strict sense of the term, it tended to become agnostic. Apart from the Averroists—who became more and more an iso-

lated sect as time went on—this happened in that mighty movement, rightly called "modern" by the later schoolmen, which began with Peter Aureolus (*ca.* 1280–1323) and came to fruition in William of Ockham (*ca.* 1295–1349 or 1350): in critical nominalism ("critical" as opposed to the dogmatic, pre-Scholastic nominalism associated with the name of Roscellinus and apparently quite dead for nearly 200 years). In contrast even to the Aristotelian, the nominalist denies all real existence to universals and grants it only to particulars, so that the nightmare of the High Scholastics—the problem of the *principium individuationis* by virtue of which The Universal Cat materializes into an infinite number of particular cats—dissolved into nothingness. As Peter Aureolus puts it, "everything is individual by virtue of itself and by nothing else" (*omnis res est se ipsa singularis et per nihil aliud*).

On the other hand, there reappeared the eternal

12

dilemma of empiricism: since the quality of reality belongs exclusively to that which can be apprehended by *notitia intuitiva,* that is, to the particular "things" directly perceived by the senses, and to the particular psychological states or acts (joy, grief, willing, etc.) directly known through inner experience, all that which is real, viz., the world of physical objects and the world of psychological processes, can never be rational, while all that which is rational, viz., the concepts distilled from these two worlds by *notitia abstractiva,* can never be real; so that all metaphysical and theological problems—including the existence of God, the immortality of the soul, and in at least one case (Nicholas of Autrecourt) even causation—can be discussed only in terms of probability.[6]

The common denominator of these new currents is, of course, subjectivism—aesthetic subjectivism in the case of the poet and humanist, religious sub-

jectivism in that of the mystic, and epistemological subjectivism in that of the nominalist. In fact, these two extremes, mysticism and nominalism, are, in a sense, nothing but opposite aspects of the same thing. Both mysticism and nominalism cut the tie between reason and faith. But mysticism—much more emphatically divorced from Scholasticism in the generation of Tauler, Suso, and John of Ruysbroeck than in that of Master Eckhart—does so in order to save the integrity of religious sentiment, while nominalism seeks to preserve the integrity of rational thought and empirical observation (Ockham explicitly denounces as "temerarious" any attempt to subject "logic, physics, and grammar" to the control of theology).

Both mysticism and nominalism throw the individual back upon the resources of private sensory and psychological experience; *intuitus* is a favorite term and central concept of Master Eckhart as well

as of Ockham. But the mystic depends on his senses as purveyors of visual images and emotional stimuli, whereas the nominalist relies on them as conveyors of reality; and the *intuitus* of the mystic is focused upon a unity beyond the distinction even between man and God and even between the Persons of the Trinity, whereas the *intuitus* of the nominalist is focused upon the multiplicity of particular things and psychological processes. Both mysticism and nominalism end up with abolishing the borderline between the finite and the infinite. But the mystic tends to infinitize the ego because he believes in the self-extinction of the human soul in God, whereas the nominalist tends to infinitize the physical world because he sees no logical contradiction in the idea of an infinite physical universe and no longer accepts the theological objections thereto. Small wonder that the nominalistic school of the four-teenth century anticipated the heliocentric system

15

of Copernicus, the geometrical analysis of Descartes, and the mechanics of Galileo and Newton.

Similarly, Late Gothic art broke up into a variety of styles reflecting these regional and ideological differences. But this variety, too, is unified by a subjectivism which, in the visual sphere, corresponds to what can be observed in intellectual life. The most characteristic expression of this subjectivism is the emergence of a perspective interpretation of space which, originating with Giotto and Duccio, began to be accepted everywhere from 1330–40. In redefining the material painting or drawing surface as an immaterial projection plane, perspective—however imperfectly handled at the beginning—renders account, not only of what is seen but also of the way it is seen under particular conditions. It records, to borrow Ockham's term, the direct *intuitus* from subject to object, thus paving the way for modern "naturalism" and lending

visual expression to the concept of the infinite; for the perspective vanishing point can be defined only as "the projection of the point in which parallels intersect."

We understandably think of perspective as a device of only the two-dimensional arts. However, this new way of seeing—or, rather, of designing with reference to the very process of sight—was bound to change the other arts as well. The sculptors and architects also began to conceive of the forms they shaped, not so much in terms of isolated solids as in terms of a comprehensive "picture space," although this "picture space" constitutes itself in the beholder's eye instead of being presented to him in a prefabricated projection. The three-dimensional media, too, supply, as it were, material for a pictorial experience. This is true of all Late Gothic sculpture—even if the pictorial principle is not carried so far as in Claus Sluter's

stagelike portal of Champmol, the typical fifteenth-century "Schnitzaltar," or those trick figures that look up a spire or down from a balcony; and it is also true of "Perpendicular" architecture in England and of the new types of hall church and semi-hall church in the Germanic countries.

All this applies not only to those innovations which may be said to reflect the empiristic and particularistic spirit of nominalism: the landscape and the interior with concomitant emphasis on genre features, and the autonomous and completely individualized portrait which represents the sitter, as Peter Aureolus would say, as "something individual by virtue of itself and nothing else," where somewhat earlier likenesses merely superimpose, as it were, a Scotian *haecceitas* upon a still typified image. It also applies to those new *Andachtsbilder* which are commonly associated with mysticism:

the *Pietà,* St. John on the Bosom of the Lord, the
Man of Sorrows, Christ in the Winepress, etc. In
their own way, such "images for worship by em-
pathy," as the term may be paraphrased, are no less
"naturalistic," often to the point of gruesomeness,
than are the portraits, landscapes, and interiors
which have been mentioned; and where the por-
traits, landscapes, and interiors induce a sense of
infinity by making the beholder aware of the unend-
ing variety and limitlessness of God's creation, the
Andachtsbilder induce a sense of infinity by permit-
ting the beholder to submerge his being in the
boundlessness of the Creator Himself. Once more
nominalism and mysticism prove to be *les extrêmes
qui se touchent.* We can easily see that these appar-
ently irreconcilable tendencies could variously in-
terpenetrate in the fourteenth century and ulti-
mately merge, for one glorious moment, in the

painting of the great Flemings, much as they did in the philosophy of their admirer, Nicholas of Cusa, who died in the same year as Roger van der Weyden.

II

During the "concentrated" phase of this astonishingly synchronous development, viz., in the period between about 1130–40 and about 1270, we can observe, it seems to me, a connection between Gothic art and Scholasticism which is more concrete than a mere "parallelism" and yet more general than those individual (and very important) "influences" which are inevitably exerted on painters, sculptors, or architects by erudite advisers. In contrast to a mere parallelism, the connection which I have in mind is a genuine cause-and-effect relation; but in contrast to an individual influence, this cause-and-effect relation comes about by diffusion rather than by direct impact. It comes

20

about by the spreading of what may be called, for want of a better term, (a mental habit)—reducing this overworked cliché to its precise Scholastic sense as a "principle that regulates the act," *principium importans ordinem ad actum.*[7] Such mental habits are at work in all and every civilization. All modern writing on history is permeated by the idea of evolution (an idea the evolution of which needs much more study than it has received thus far and seems to enter a critical phase right now); and all of us, without a thorough knowledge of biochemistry or psychoanalysis, speak with the greatest of ease of vitamin deficiencies, allergies, mother fixations, and inferiority complexes.

Often it is difficult or impossible to single out one habit-forming force from many others and to imagine the channels of transmission. However, the period from about 1130–40 to about 1270 and the "100-mile zone around Paris" constitute an ex-

ception. In this tight little sphere Scholasticism
possessed what amounted to a monopoly in educa-
tion. By and large, intellectual training shifted from
the monastic schools to institutions urban rather
than rural, cosmopolitan rather than regional, and,
so to speak, only half ecclesiastic: to the cathedral
schools, the universities, and the *studia* of the new
mendicant orders—nearly all of them products of
the thirteenth century—whose members played an
increasingly important role within the universities
themselves. And as the Scholastic movement, pre-
pared by Benedictine learning and initiated by Lan-
franc and Anselm of Bec, was carried on and
brought to fruition by the Dominicans and Francis-
cans, so did the Gothic style, prepared in Bene-
dictine monasteries and initiated by Suger of St.-
Denis, achieve its culmination in the great city
churches. It is significant that during the Roman-
esque period the greatest names in architectural

22

history are those of Benedictine abbeys, in the High Gothic period those of cathedrals, and in the Late Gothic periods those of parish churches.

It is not very probable that the builders of Gothic structures read Gilbert de la Porrée or Thomas Aquinas in the original. But they were exposed to the Scholastic point of view in innumerable other ways, quite apart from the fact that their own work automatically brought them into a working association with those who devised the liturgical and iconographic programs. They had gone to school; they listened to sermons; they could attend the public *disputationes de quolibet* which, dealing as they did with all imaginable questions of the day, had developed into social events not unlike our operas, concerts, or public lectures;[8] and they could come into profitable contact with the learned on many other occasions. The very fact that neither the natural sciences nor the humanities nor even

23

mathematics had evolved their special esoteric methods and terminologies kept the whole of human knowledge within the range of the normal, non-specialized intellect; and—perhaps the most important point—the entire social system was rapidly changing toward an urban professionalism. Not as yet hardened into the later guild and "Bauhütten" systems, it provided a meeting ground where the priest and the layman, the poet and the lawyer, the scholar and the artisan could get together on terms of near-equality. There appeared the professional, town-dwelling publisher (*stationarius*, hence our "stationer"), who, more or less strictly supervised by a university, produced manuscript books *en masse* with the aid of hired scribes, together with the bookseller (mentioned from about 1170), the book-lender, the bookbinder, and the book-illuminator (by the end of the thirteenth

24

century the *enlumineurs* already occupied a whole street in Paris); the professional, town-dwelling painter, sculptor, and jeweller; the professional, town-dwelling scholar who, though usually a cleric, yet devoted the substance of his life to writing and teaching (hence the words ''scholastic'' and ''scholasticism''); and, last but not least, the professional, town-dwelling architect.

This professional architect—''professional'' in contradistinction to the monastic equivalent of what in modern times is called the gentleman architect—would rise from the ranks and supervise the work in person. In doing so he grew into a man of the world, widely travelled, often well read, and enjoying a social prestige unequalled before and unsurpassed since. Freely selected *propter sagacitatem ingenii,* he drew a salary envied by the lower clergy and would appear at the site, ''carrying

gloves and a rod" (*virga*), to give those curt orders that became a byword in French literature whenever a writer wished to describe a man who does things well and with superior assurance: "*Par cy me le taille.*"⁹ His portrait would figure together with that of the founding bishop in the "labyrinths" of the great cathedrals. After Hugues Libergier, the master of the lost St.-Nicaise in Reims, had died in 1263, he was accorded the unheard-of honor of being immortalized in an effigy that shows him not only clad in something like academic garb but also carrying a model of "his" church—a privilege previously accorded only to princely donors (fig. 1). And Pierre de Montereau—indeed the most logical architect who ever lived—is designated on his tombstone in St.-Germain-des-Prés as "*Doctor* Lathomorum": by 1267, it seems, the architect himself had come to be looked upon as a kind of Scholastic.

26

And Scholasticism

III

When asking in what manner the mental habit induced by Early and High Scholasticism may have affected the formation of Early and High Gothic architecture, we shall do well to disregard the notional content of the doctrine and to concentrate, to borrow a term from the schoolmen themselves, upon its *modus operandi*. The changing tenets in such matters as the relation between soul and body or the problem of universals vs. particulars naturally were reflected in the representational arts rather than in architecture. True, the architect lived in close contact with the sculptors, glass painters, wood carvers, etc., whose work he studied wherever he went (witness the "Album" of Villard de Honnecourt), whom he engaged and supervised in his own enterprises, and to whom he had to transmit an iconographic program which, we remember, he could work out only in close

cooperation with a scholastic adviser. But in doing all this, he assimilated and conveyed rather than applied the substance of contemporary thought. What he who "devised the form of the building while not himself manipulating its matter"[10] could and did apply, directly and *qua* architect, was rather that peculiar method of procedure which must have been the first thing to impress itself upon the mind of the layman whenever it came in touch with that of the schoolman.

This method of procedure follows, as every *modus operandi* does, from a *modus essendi;*[11] it follows from the very *raison d'être* of Early and High Scholasticism, which is to establish the unity of truth. The men of the twelfth and thirteenth centuries attempted a task not yet clearly envisaged by their forerunners and ruefully to be abandoned by their successors, the mystics and the nominalists: the task of writing a permanent peace treaty be-

tween faith and reason. "Sacred doctrine," says Thomas Aquinas, "makes use of human reason, not to prove faith but to make clear (*manifestare*) whatever else is set forth in this doctrine."[12] This means that human reason can never hope to furnish direct proof of such articles of faith as the tri-personal structure of the Trinity, the Incarnation, the temporality of Creation, etc.; but that it can, and does, elucidate or clarify these articles.

First, human reason can furnish direct and complete proof for whatever can be deduced from principles other than revelation, that is, for all ethical, physical, and metaphysical tenets including the very *praeambula fidei*, such as the existence (though not the essence) of God, which can be proved by an argument from effect to cause.[13] Second, it can elucidate the content of revelation itself: by argument, though merely negatively, it can refute all rational objections against the Articles of

Ref. note #23

29

Faith—objections that must of necessity be either false or inconclusive;[14] and positively, though not by argument, it can supply *similitudines* which "manifest" the mysteries by way of analogy, as when the relation between the Three Persons of the Trinity is likened to that between being, knowledge and love in our own mind,[15] or divine creation to the work of the human artist.[16]

Manifestatio, then, elucidation or clarification, is what I would call the first controlling principle of Early and High Scholasticism.[17] But in order to put this principle into operation on the highest possible plane—elucidation of faith by reason—it had to be applied to reason itself: if faith had to be "manifested" through a system of thought complete and self-sufficient within its own limits yet setting itself apart from the realm of revelation, it became necessary to "manifest" the completeness, self-suffi-

30

ciency, and limitedness of the system of thought. And this could be done only by a scheme of literary presentation that would elucidate the very processes of reasoning to the reader's imagination just as reasoning was supposed to elucidate the very nature of faith to his intellect. Hence the much derided schematism or formalism of Scholastic writing which reached its climax in the classic *Summa*[18] with its three requirements of (1) totality (sufficient enumeration), (2) arrangement according to a system of homologous parts and parts of parts (sufficient articulation), and (3) distinctness and deductive cogency (sufficient interrelation)— all this enhanced by the literary equivalent of Thomas Aquinas's *similitudines*: suggestive terminology, *parallelismus membrorum,* and rhyme. A well-known instance of the two latter devices—both artistic as well as mnemonic—is St. Bonaventure's

succinct defense of religious images which he declares admissible *"propter simplicium ruditatem, propter affectuum tarditatem, propter memoriae labilitatem."*[19]

We take it for granted that major works of scholarship, especially systems of philosophy and doctoral theses, are organized according to a scheme of division and subdivision, condensable into a table of contents or synopsis, where all parts denoted by numbers or letters of the same class are on the same logical level; so that the same relation of subordination obtains between, say, sub-section (a), section (1), chapter (I) and book (A) as does between, say, sub-section (b), section (5), chapter (IV) and book (C). However, this kind of systematic articulation was quite unknown until the advent of Scholasticism.[20] Classical writings (except perhaps for those that consisted of denumerable items such as collections of short poems or treatises on mathematics) were merely divided into "books."

And Scholasticism

When we wish to give what we, unsuspecting heirs
to Scholasticism, call an exact quotation, we must
either refer to the pages of a printed edition con-
ventionally accepted as authoritative (as we do with
Plato and Aristotle), or to a scheme introduced by
some humanist of the Renaissance as when we quote
a Vitruvius passage as "VII, 1, 3."

It was, it seems, not until the earlier part of the
Middle Ages that "books" were divided into num-
bered "chapters" the sequence of which did not,
however, imply or reflect a system of logical subor-
dination; and it was not until the thirteenth cen-
tury that the great treatises were organized accord-
ing to an overall plan *secundum ordinem disciplinae*[21]
so that the reader is led, step by step, from one
proposition to the other and is always kept in-
formed as to the progress of this process. The whole
is divided into *partes* which—like the Second Part
of Thomas Aquinas's *Summa Theologiae*—could be

divided into smaller *partes;* the *partes* into *membra,* *quaestiones* or *distinctiones,* and these into *articuli.*[22] Within the *articuli,* the discussion proceeds according to a dialectical scheme involving further subdivision, and almost every concept is split up into two or more meanings (*intendi potest dupliciter,* *tripliciter,* etc.) according to its varying relation to others. On the other hand, a number of *membra,* *quaestiones,* or *distinctiones* are often tied together into a group. The first of the three *partes* that constitute Thomas Aquinas's *Summa Theologiae,* a veritable orgy both of logic and Trinitarian symbolism, is an excellent case in point.[23]

All this does not mean, of course, that the Scholastics thought in more orderly and logical fashion than Plato and Aristotle; but it does mean that they, in contrast to Plato and Aristotle, felt compelled to make the orderliness and logic of their thought palpably explicit—that the principle of

manifestatio which determined the direction and
scope of their thinking also controlled its exposition
and subjected this exposition to what may be
termed the POSTULATE OF CLARIFICATION FOR
CLARIFICATION'S SAKE.

<div align="center">IV</div>

Within Scholasticism itself this principle re-
sulted not only in the explicit unfolding of what,
though necessary, might have been allowed to re-
main implicit, but also, occasionally, in the intro-
duction of what was not necessary at all, or in the
neglect of a natural order of presentation in favor of
an artificial symmetry. In the very Prologue of the
Summa Theologiae, Thomas Aquinas complains, with
an eye on his forerunners, of "the multiplication of
useless questions, articles, and arguments" and of a
tendency to present the subject "not according to
the order of the discipline itself but rather accord-

ing to the requirements of literary exposition." However, the passion for "clarification" imparted itself—quite naturally in view of the educational monopoly of Scholasticism—to virtually every mind engaged in cultural pursuits; it grew into a "mental habit."

Whether we read a treatise on medicine, a handbook of classical mythology such as Ridewall's *Fulgentius Metaforalis*, a political propaganda sheet, the eulogy of a ruler, or a biography of Ovid,[24] we always find the same obsession with systematic division and subdivision, methodical demonstration, terminology, *parallelismus membrorum,* and rhyme. Dante's *Divina Commedia* is Scholastic, not only in much of its content but also in its deliberately Trinitarian form.[25] In the *Vita Nuova* the poet himself goes out of his way to analyze the tenor of each sonnet and *canzone* by "parts" and "parts of parts" in perfectly Scholastic fashion, whereas Petrarch,

half a century later, was to conceive of the struc-
ture of his songs in terms of euphony rather than
logic. "I thought of changing the order of the four
stanzas so that the first quatrain and the first terzina
would have come second and vice versa," he re-
marks of one sonnet, "but I gave it up because then
the fuller sound would have been in the middle and
the hollower at the beginning and the end."[26]

What applies to prose and poetry applies no less
emphatically to the arts. Modern Gestalt psychol-
ogy, in contrast to the doctrine of the nineteenth
century and very much in harmony with that of the
thirteenth, "refuses to reserve the capacity of syn-
thesis to the higher faculties of the human mind"
and stresses "the formative powers of the sensory
processes." Perception itself is now credited—and
I quote—with a kind of "intelligence" that "or-
ganizes the sensory material under the pattern of
simple, 'good' Gestalten" in an "*effort of the organ-*

37

ism to assimilate stimuli to its own organization";[27] all of which is the modern way of expressing precisely what Thomas Aquinas meant when he wrote: "the senses delight in things duly proportioned *as in something akin to them; for, the sense, too, is a kind of reason as is every cognitive power*" ("*sensus delectantur in rebus debite proportionatis sicut in sibi similibus; nam et sensus ratio quaedam est, et omnis virtus cognoscitiva*").[28]

Small wonder, then, that a mentality which deemed it necessary to make faith "clearer" by an appeal to reason and to make reason "clearer" by an appeal to imagination, also felt bound to make imagination "clearer" by an appeal to the senses. Indirectly, this preoccupation affected even philosophical and theological literature in that the intellectual articulation of the subject matter implies the acoustic articulation of speech by recurrent phrases, and the visual articulation of the written

page by rubrics, numbers, and paragraphs. Directly, it affected all the arts. As music became articulated through an exact and systematic division of time (it was the Paris school of the thirteenth century that introduced the mensural notation still in use and still referred to, in England at least, by the original terms of "breve," "semibreve," "minim," etc.), so did the visual arts become articulated through an exact and systematic division of space, resulting in a "clarification for clarification's sake" of narrative contexts in the representational arts, and of functional contexts in architecture.

In the field of the representational arts this might be demonstrated by an analysis of almost any single figure; but it is still more evident in the arrangement of ensembles. Barring such accidents as happened at Magdeburg or Bamberg, the composition of a High Gothic portal, for example, tends to be subjected to a strict and fairly standardized scheme

which, in imposing order upon the formal arrange-
ment, simultaneously clarifies the narrative con-
tent. Suffice it to compare the beautiful but as yet
not "clarified" Last Judgement portal of Autun
(fig. 2) with those of Paris or Amiens (fig. 3) where
—in spite of an even greater wealth of motifs—con-
summate clarity prevails. The tympanum is sharply
divided into three registers (a device unknown in
Romanesque save only such well-motivated excep-
tions as St.-Ursin-de-Bourges and Pompierre), the
Deësis being separated from the Damned and the
Elect, and these again from the Resurrected. The
Apostles, precariously included in the tympanum
at Autun, are placed in the embrasures where they
surmount the twelve Virtues and their counter-
parts (developed from the customary heptad by a
Scholastically correct subdivision of Justice) in
such a manner that Fortitude corresponds to St.
Peter, the "rock," and Charity to St. Paul, the

author of *I Corinthians,* 13; and the Wise and Foolish Virgins, antetypes of the Elect and the Damned, have been added in the doorposts by way of a marginal gloss.

In painting, we can observe the process of clarification *in vitro,* so to speak. We can compare, by an extraordinary chance, a series of miniatures of about 1250 with their direct models, produced in the latter half of the eleventh century probably after 1079 and certainly before 1096 (fig. 4–7).[29] The two best known (fig. 6 and 7) represent King Philip I conferring privileges and donations, among them the church of St.-Samson, upon the Priory of St.-Martin-des-Champs. But where the Early Romanesque prototype, an unframed pen drawing, shows a jumble of figures, buildings, and inscriptions, the High Gothic copy is a carefully organized picture. It pulls the whole together by a frame (adding, in a new feeling for realism and communal

dignity, a consecration ceremony at the bottom). Neatly segregating the different elements, it divides the area within the frame into four sharply delimited fields which correspond to the categories of the King, the Ecclesiastical Structures, the Episcopate, and the Secular Nobility. The two buildings— St.-Martin itself and St.-Samson—are not only brought up to the same level but also represented in pure side elevation instead of being shown in mixed projection. The fact that the dignitaries, formerly unattended and uniformly frontalized, are accompanied by some minor personages and have acquired the faculties of movement and intercommunication enhances rather than weakens their individual significance; and the only ecclesiastic who, for good reasons, has found his place among the counts and princes, Archdeacon Drogo of Paris, is clearly set off against them by his chasuble and mitre.

And Scholasticism

It was, however, in architecture that the habit of clarification achieved its greatest triumphs. As High Scholasticism was governed by the principle of *manifestatio,* so was High Gothic architecture dominated—as already observed by Suger—by what may be called the "principle of transparency." Pre-Scholasticism had insulated faith from reason by an impervious barrier much as a Romanesque structure (fig. 8) conveys the impression of a space determinate and impenetrable, whether we find ourselves inside or outside the edifice. Mysticism was to drown reason in faith, and nominalism was to completely disconnect one from the other; and both these attitudes may be said to find expression in the Late Gothic hall church. Its barnlike shell encloses an often wildly pictorial and always apparently boundless interior (fig. 9) and thus creates a space determinate and impenetrable from without but indeterminate and penetrable from within.

High Scholastic philosophy, however, severely limited the sanctuary of faith from the sphere of rational knowledge yet insisted that the content of this sanctuary remain clearly discernible. And so did High Gothic architecture delimit interior volume from exterior space yet insist that it project itself, as it were, through the encompassing structure (fig. 15 and 16); so that, for example, the cross section of the nave can be read off from the façade (fig. 34).

Like the High Scholastic *Summa*, the High Gothic cathedral aimed, first of all, at "totality" and therefore tended to approximate, by synthesis as well as elimination, one perfect and final solution; we may therefore speak of *the* High Gothic plan or *the* High Gothic system with much more confidence than would be possible in any other period. In its imagery, the High Gothic cathedral sought to embody the whole of Christian knowledge, theological,

moral, natural, and historical, with everything in its place and that which no longer found its place, suppressed. In structural design, it similarly sought to synthesize all major motifs handed down by separate channels and finally achieved an unparalleled balance between the basilica and the central plan type, suppressing all elements that might endanger this balance, such as the crypt, the galleries, and towers other than the two in front.

The second requirement of Scholastic writing, "arrangement according to a system of homologous parts and parts of parts," is most graphically expressed in the uniform division and subdivision of the whole structure. Instead of the Romanesque variety of western and eastern vaulting forms, often appearing in one and the same building (groin vaults, rib vaults, barrels, domes, and half-domes), we have the newly developed rib vault exclusively so that the vaults of even the apse, the chapels and

45

the ambulatory no longer differ in kind from those
of the nave and transept (fig. 10 and 11). Since
Amiens, rounded surfaces were entirely eliminated,
except, of course, for the webbing of the vaults.
Instead of the contrast that normally existed be-
tween tripartite naves and undivided transepts (or
quinquepartite naves and tripartite transepts) we
have tripartition in both cases; and instead of the
disparity (either in size, or in the type of covering,
or in both) between the bays of the high nave and
those of the side aisles, we have the "uniform
travée," in which one rib-vaulted central bay con-
nects with one rib-vaulted aisle bay on either side.
The whole is thus composed of smallest units—one
might almost speak of *articuli*—which are homolo-
gous in that they are all triangular in groundplan
and in that each of these triangles shares its sides
with its neighbors.

And Scholasticism

As a result of this homology we perceive what corresponds to the hierarchy of "logical levels" in a well-organized Scholastic treatise. Dividing the entire structure, as was customary in the period itself, into three main parts, the nave, the transept, and the chevet (which in turn comprises the fore-choir and the choir proper), and distinguishing, within these parts, between high nave and side-aisles, on the one hand, and between apse, ambulatory, and hemicycle of chapels, on the other, we can observe analogous relations to obtain: first, between each central bay, the whole of the central nave, and the entire nave, transept or fore-choir, respectively; second, between each side aisle bay, the whole of each side aisle, and the entire nave, transept or fore-choir, respectively; third, between each sector of the apse, the whole apse, and the entire choir; fourth, between each section

of the ambulatory, the whole ambulatory and the entire choir; and fifth, between each chapel, the whole hemicycle of chapels, and the entire choir.

It is not possible here—nor is it necessary—to describe how this principle of progressive divisibility (or, to look at it the other way, multiplicability) increasingly affected the entire edifice down to the smallest detail. At the height of the development, supports were divided and subdivided into main piers, major shafts, minor shafts, and still minor shafts; the tracery of windows, triforia, and blind arcades into primary, secondary, and tertiary mullions and profiles; ribs and arches into a series of moldings (fig. 22). It may be mentioned, however, that the very principle of homology that controls the whole process implies and accounts for the relative uniformity which distinguishes the High Gothic vocabulary from the Romanesque. All parts that are on the same "logical level"—and this is

especially noticeable in those decorative and repre-
sentational features which, in architecture, corre-
spond to Thomas Aquinas's *similitudines*—came to
be conceived of as members of one class, so that the
enormous variety in, for instance, the shape of
canopies, the decoration of socles and archevaults,
and, above all, the form of piers and capitals tended
to be suppressed in favor of standard types admit-
ting only of such variations as would occur in
nature among individuals of one species. Even in
the world of fashion the thirteenth century is dis-
tinguished by a reasonableness and uniformity
(even as far as the difference between masculine
and feminine costumes is concerned) which was
equally foreign to the preceding and to the follow-
ing period.

The theoretically illimited fractionization of the
edifice is limited by what corresponds to the third
requirement of Scholastic writing: "distinctness

and deductive cogency.'' According to classic High Gothic standards the individual elements, while forming an indiscerptible whole, yet must proclaim their identity by remaining clearly separated from each other—the shafts from the wall or the core of the pier, the ribs from their neighbors, all vertical members from their arches; and there must be an unequivocal correlation between them. We must be able to tell which element belongs to which, from which results what might be called a ''postulate of mutual inferability''—not in dimensions, as in classical architecture, but in conformation. While Late Gothic permitted, even delighted in, flowing transitions and interpenetrations, and loved to defy the rule of correlation by, for instance, over-membrification of the ceiling and under-membrification of the supports (fig. 9), the classic style demands that we be able to infer, not only the interior from the exterior or the shape of

the side aisles from that of the central nave but also, say, the organization of the whole system from the cross section of one pier.

The last-named instance is especially instructive. In order to establish uniformity among all the supports, including those in the *rond-point* (and also, perhaps, in deference to a latent classicizing impulse), the builders of the most important structures after Senlis, Noyon, and Sens had abandoned the compound pier and had sprung the nave arcades from monocylindrical piers (fig. 18).[30] This, of course, made it impossible to "express," as it were, the superstructure in the conformation of the supports. In order to accomplish this and yet preserve the now accepted form, there was invented the *pilier cantonné*, the columnar pier with four applied colonnettes (fig. 19–21). However, while this type, adopted in Chartres, Reims, and Amiens,[31] permitted the "expression" of the

transverse ribs of the nave and side aisles as well as the longitudinal arches of the nave arcades, it did not permit the "expression" of the diagonals (fig. 51). The final solution was found (in St.-Denis) by the resumption of the compound pier, reorganized, however, in such a way that it "expressed" every feature of a High Gothic superstructure (fig. 22). The inner profile of the nave arches is taken up by a strong colonnette, their outer profile by a slighter one, the transverse and diagonal ribs of the nave by three tall shafts (the central one stronger than the two others) to which correspond three analogous colonnettes for the transverse and diagonal ribs of the side-aisles; and even what remains of the nave wall—the only element that stubbornly persisted in being "wall"—is "manifested" in the rectangular, still "mural" core of the pier itself (fig. 52).[32]

This is indeed "rationalism." It is not quite the

rationalism conceived by Choisy and Viollet-le-Duc,[33] for the compound piers of St.-Denis have no functional, let alone economic, advantages over the *piliers cantonnés* of Reims or Amiens; but neither is it—as Pol Abraham would have us believe—"illusionism."[34] From the point of view of the modern archaeologist this famous quarrel between Pol Abraham and the functionalists can be settled by the reasonable compromise proposed by Marcel Aubert and Henri Focillon and, as a matter of fact, already envisaged by Ernst Gall.[35]

No doubt Pol Abraham is wrong in denying the practical value of even such features as ribs and flying buttresses. The skeleton of "independently constructed ribs" (*arcus singulariter voluti*),[36] much heavier and more robust than their graceful profiles lead us to believe (fig. 24), did have considerable technical advantages in that it made it possible to vault the webs in freehand (which saved much wood

53

and labor for centering) and to reduce their thickness; for according to complicated modern calculations, the simple result of which was so well known, empirically, to the Gothic builders that they took it for granted in their writings,[37] an arch twice as thick as another is, *ceteris paribus,* just twice as strong; which means that ribs do reinforce the vault. That Gothic vaults have been known to survive when the ribs were blasted away by artillery fire in World War I does not prove that they would have survived had they been deprived of their ribs after seven weeks instead of after seven centuries; for ancient masonry will hold together by sheer cohesion so that major portions even of the walls may be seen hanging, as it were, in position after the loss of their supports (fig. 25).[38]

Buttresses and flying buttresses do counteract the deformative forces which threaten the stability of every vault.[39] And that the Gothic masters—

excepting only those headstrong Milanese ignora-
muses who blandly contended that ''no thrust upon
the buttresses is exerted by vaults with pointed
arches''—were fully aware of this is documented
by several texts and attested to by their very trade
expressions such as *contrefort, bouterec* (hence our
''buttress''), *arc-boutant,* or the German *strebe*
(hence, interestingly enough, the Spanish *estribo*),
all of which denote the function of a thrust or
counterthrust.[40] The upper range of flying but-
tresses—subsequently added in Chartres but
planned from the outset in Reims and in most
major edifices after that—may well have been
intended to lend support to the steeper, heavier
roofs and, possibly, to resist the wind pressure
against them.[41] Even tracery has a certain practical
value in that it facilitates the installation and aids
the preservation of glass.

On the other hand, it is equally true that the

earliest genuine ribs appear in connection with heavy groin vaults, where they could not have been constructed "independently" and thus would neither have saved centering nor would have had much statical value afterwards (fig. 23);[42] it is also true that the flying buttresses of Chartres, their functional importance notwithstanding, appealed to the aesthetic sense so much so that the master of the beautiful Madonna in the north transept of Reims Cathedral repeated them, *en miniature,* in the Madonna's aedicule (fig. 26 and 27). The admirable architect of St.-Ouen in Rouen, whose design most closely approximates the modern standards of statical efficiency,[43] managed without an upper range of flying buttresses. And on no account could there have been any practical reason for that elaboration of the buttressing system which transforms it into a filigree of colonnettes, tabernacles, pinnacles, and tracery (fig. 29). The largest

of all stained glass windows, the west window of Chartres, has survived seven centuries without any tracery; and that the blind tracery applied to solid surfaces has no technical importance whatsoever goes without saying.

However, this whole discussion is not to the point. With reference to twelfth and thirteenth century architecture, the alternative, "all is function—all is illusion," is as little valid as would be, with reference to twelfth and thirteenth century philosophy, the alternative "all is search for truth —all is intellectual gymnastics and oratory." The ribs of Caen and Durham, not as yet *singulariter voluti*, began by saying something before being able to do it. The flying buttresses of Caen and Durham, still hidden beneath the roofs of the side aisles (fig. 28), began by doing something before being permitted to say so. Ultimately, the flying buttress learned to talk, the rib learned to work, and

both learned to proclaim what they were doing in language more circumstantial, explicit, and ornate than was necessary for mere efficiency; and this applies also to the conformation of the piers and the tracery which had been talking as well as working all the time.

We are faced neither with "rationalism" in a purely functionalistic sense nor with "illusion" in the sense of modern *l'art pour l'art* aesthetics. We are faced with what may be termed a "visual logic" illustrative of Thomas Aquinas's *nam et sensus ratio quaedam est.* A man imbued with the Scholastic habit would look upon the mode of architectural presentation, just as he looked upon the mode of literary presentation, from the point of view of *manifestatio.* He would have taken it for granted that the primary purpose of the many elements that compose a cathedral was to ensure stability, just as he took it for granted that the

primary purpose of the many elements that constitute a *Summa* was to ensure validity.

But he would not have been satisfied had not the membrification of the edifice permitted him to re-experience the very processes of architectural composition just as the membrification of the *Summa* permitted him to re-experience the very processes of cogitation. To him, the panoply of shafts, ribs, buttresses, tracery, pinnacles, and crockets was a self-analysis and self-explication of architecture much as the customary apparatus of parts, distinctions, questions, and articles was, to him, a self-analysis and self-explication of reason. Where the humanistic mind demanded a maximum of "harmony" (impeccable diction in writing, impeccable proportion, so sorely missed in Gothic structures by Vasari,[44] in architecture), the Scholastic mind demanded a maximum of explicitness. It accepted and insisted upon a gratuitous clarifica-

tion of function through form just as it accepted and insisted upon a gratuitous clarification of thought through language.

v

To reach its classic phase the Gothic style needed no more than a hundred years—from Suger's St.-Denis to Pierre de Montereau's; and we should expect to see this rapid and uniquely concentrated development proceed with unparalleled consistency and directness. Such, however, is not the case. Consistent the development is, but it is not direct. On the contrary, when observing the evolution from the beginning to the "final solutions," we receive the impression that it went on almost after the fashion of a "jumping procession," taking two steps forward and then one backward, as though the builders were deliberately placing obstacles in their own way. And this can be observed not only

under such adverse financial or geographical conditions as normally produce a retrogression by default, so to speak, but in monuments of the very first rank.

The "final" solution of the general plan was reached, we remember, in a basilica having a tripartite nave; a transept, likewise tripartite and distinctly projecting from the nave but merging, as it were, into the quinquepartite fore-choir; a concentric chevet with ambulatory and radiating chapels; and only two towers in front (fig. 11 and 16). At first glance, the natural thing would have been a rectilinear development starting from St.-Germer and St.-Lucien-de-Beauvais which anticipate nearly all these features in the early twelfth century. Instead, we find a dramatic struggle between two contrasting solutions each of which seems to lead away from the ultimate result. Suger's St.-Denis and Sens Cathedral (fig. 12) pro-

vided a strictly longitudinal model, with only two
towers in front and the transept either stunted or
entirely omitted—a plan adopted in Notre-Dame
of Paris and Mantes, and still retained in the High
Gothic Cathedral of Bourges.[45] As though in protest
against this, the masters of Laon (fig. 13 and 14)—
possibly swayed by the unique location of their
cathedral on the crest of a hill—reverted to the
Germanic idea of a multinomial group with a pro-
jecting, tripartite transept and many towers (as
exemplified by the Cathedral of Tournai), and it
took the succeeding generations two more cathe-
drals to get rid of the extra towers surmounting
the transept and the crossing. Chartres was planned
with no less than nine towers; Reims, like Laon
itself, with seven (fig. 15); and it was not until
Amiens (fig. 16) that the disposition with only two
front towers was reinstated.

Similarly, the "final" solution of the nave com-

position (fig. 19–22) implied, in plan, a succession of uniform, oblong, quadrupartite vaults and uniform, articulated piers; and, in elevation, a triadic sequence of arcades, triforium, and clerestory. Again it would seem that this solution might have been reached by going ahead, straightforwardly, from such early twelfth-century prototypes as St.-Etienne-de-Beauvais or Lessay in Normandy (fig. 17). Instead, all major structures prior to Soissons and Chartres sport sixpartite vaults over monocylindrical piers (fig. 18) or even revert to the antiquated "alternating system." Their elevation shows galleries which, in the most important buildings later than Noyon, are combined with a triforium (or, as in Notre-Dame-de-Paris, with the equivalent thereof) into a four-story arrangement (fig. 18).[46]

In retrospect, it is easy to see that what seems to be an arbitrary deviation from the direct road is in

reality an indispensable prerequisite of the "final" solution. Had it not been for the adoption of the many-towered group in Laon, no balance would have been achieved between the longitudinal and the centralizing tendencies, much less a unification of a fully developed chevet with an equally fully developed tripartite transept. Had it not been for the adoption of sixpartite vaults and a four-story elevation, it would not have been possible to reconcile the ideal of a uniform progression from west to east with the ideals of transparency and verticalism. In both cases the "final" solutions were arrived at by the ACCEPTANCE AND ULTIMATE RECONCILIA-TION OF CONTRADICTORY POSSIBILITIES.[47] Here we come upon the second controlling principle of Scholasticism. And if the first—*manifestatio*—helped us to understand how classic High Gothic looks, this second—*concordantia*—may help us to understand how classic High Gothic came about.

64

All that mediaeval man could know about divine revelation, and much of what he held to be true in other respects, was transmitted by the authorities (*auctoritates*): primarily, by the canonical books of the Bible which furnished arguments "intrinsic and irrefutable" (*proprie et ex necessitate*); secondarily, by the teachings of the Fathers of the Church, which furnished arguments "intrinsic" though merely "probable," and of the "philosophers" which furnished arguments "not intrinsic" (*extranea*) and merely probable for this very reason.[48] Now, it could not escape notice that these authorities, even passages of Scripture itself, often conflicted with one another. There was no other way out than to accept them just the same and to interpret and reinterpret them over and over again until they could be reconciled. This had been done by theologians from the earliest days. But the problem was not posed as a matter of principle until Abe-

lard wrote his famous *Sic et Non,* wherein he showed the authorities, including Scripture, disagreeing on 158 important points—from the initial problem whether or not faith ought to seek support in human reason down to such special questions as the permissibility of suicide (155) or concubinage (124). Such a systematic collection and confrontation of conflicting authorities had long been a practice of the canonists; but law, though God-given, was, after all, man-made. Abelard showed himself very conscious of his boldness in exposing the "differences or even contradictions" (*ab invicem diversa, verum etiam invicem adversa*) within the very sources of revelation when he wrote that this "would stimulate the reader all the more vigorously to inquire into the truth the more the authority of Scripture is extolled."[49]

After having laid down, in his splendid introduction, the basic principles of textual criticism (in-

And Scholasticism

cluding the possibility of clerical error in even a
Gospel, such as the ascription of a prophesy of
Zacharias to Jeremias in *Matthew*, xxvii, 9), Abelard
mischievously refrained from proposing solutions.
But it was inevitable that such solutions should be
worked out, and this procedure became a more and
more important part, perhaps the most important
part, of the Scholastic method. Roger Bacon,
shrewdly observing the diverse origins of this Scho-
lastic method, reduced it to three components:
"division into many parts as do the dialecticians;
rhythmical consonances as do the grammarians;
and forced harmonizations (*concordiae violentes*) as
used by the jurists."[50]

It was this technique of reconciling the seem-
ingly irreconcilable, perfected into a fine art through
the assimilation of Aristotelian logic, that deter-
mined the form of academic instruction, the ritual
of the public *disputationes de quolibet* already men-

tioned, and, above all, the process of argumentation in the Scholastic writings themselves. Every topic (e.g., the content of every *articulus* in the *Summa Theologiae*) had to be formulated as a *quaestio* the discussion of which begins with the alignment of one set of authorities (*videtur quod . . .*) against the other (*sed contra . . .*), proceeds to the solution (*respondeo dicendum . . .*), and is followed by an individual critique of the arguments rejected (*ad primum, ad secundum,* etc.)—rejected, that is, only insofar as the interpretation, not the validity, of the authorities is concerned.

Needless to say, this principle was bound to form a mental habit no less decisive and all-embracing than that of unconditional clarification. Combative though they were in dealing with each other, the Scholastics of the twelfth and thirteenth centuries were unanimous in accepting the authorities and prided themselves on their skill in understanding

and exploiting them rather than on the originality of their own thought. One feels the breath of a new era when William of Ockham, whose nominalism was to cut the ties between reason and faith and who could say: "What Aristotle thought about this, I don't care,"[51] goes out of his way to deny the influence of his most important forerunner, Peter Aureolus.[52]

An attitude similar to that of High Scholasticism must be presupposed in the builders of the High Gothic cathedrals. For these architects the great structures of the past had an *auctoritas* quite similar to that which the Fathers had for the schoolmen. Of two apparently contradictory motifs, both of them sanctioned by authority, one could not simply be rejected in favor of the other. They had to be worked through to the limit and they had to be reconciled in the end; much as a saying of St. Augustine had ultimately to be reconciled with one of

St. Ambrose. And this, I believe, accounts to some extent for the apparently erratic yet stubbornly consistent evolution of Early and High Gothic architecture; it, too, proceeded according to the scheme: *videtur quod—sed contra—respondeo dicendum*.

I should like to illustrate this, most cursorily, by three characteristic Gothic "problems"—or, as we might say, *quaestiones*: the rose window in the west façade, the organization of the wall beneath the clerestory, and the conformation of the nave piers.

So far as we know, west façades were pierced by normal windows, and not by roses, until Suger— perhaps impressed by the magnificent specimen in the north transept of St.-Etienne in Beauvais— chose to adopt the motif for the west façade of St.- Denis, superimposing a magnificent *Non* upon the *Sic* of the big window beneath it (fig. 30). The further development of this innovation was fraught

with great difficulties.[53] If the diameter of the rose remained comparatively small or was even reduced (as in Senlis), an awkward and "un-Gothic" space of wall was left on either side as well as underneath. If the rose was enlarged to approximately the full width of the nave, it tended to conflict with the nave vaults when seen from within and required on the exterior as wide an interval as possible between the buttresses of the façade, thus uncomfortably diminishing the space available for side portals. Apart from this, the very concept of an isolated, circular unit conflicted with the ideals of Gothic taste in general, and with the ideal of a Gothic façade—adequate representation of the interior— in particular.

Small wonder that Normandy and—with a very few exceptions—England plainly rejected the whole idea and simply enlarged the traditional window until it filled the available space (while Italy,

71

characteristically, greeted the rose with enthusiasm because of its *au fond* anti-Gothic character).[54] The architects of the Royal Domain and Champagne, however, felt bound to accept a motif sanctioned by the authority of St.-Denis, and it is almost amusing to observe their perplexities.

The architect of Notre-Dame (fig. 31) was lucky in that he had a quinquepartite nave. Courageously though not quite honestly ignoring this fact, he built a tripartite facade the lateral sections of which were so wide in comparison to the middle that all problems were easily solved. The master of Mantes, however, had to make the distance between the buttresses considerably smaller than the width of the nave (as small, in fact, as was technically possible); and even then the space for the side portals was far from ample. The master of Laon, who wanted both a full-sized rose and generous side portals, resorted to a trick; he broke the buttresses

so that their lower sections, framing the central portal, are closer together than the upper ones that frame the rose; and then he concealed the break by the enormous fig-leaf of his porch (fig. 32). The masters of Amiens, finally, with their inordinately slender nave, needed two galleries (one with kings, the other without) to fill the space between the rose and the portals (fig. 33).

It was not until 1240–50 that the school of Reims, culminating in St.-Nicaise, discovered the "final" solution (fig. 34 and 35): the rose was inscribed within the pointed arch of a huge window, thereby becoming elastic, as it were. It could be lowered so as not to conflict with the vaults; the space beneath it could be filled with mullions and glass. The whole arrangement mirrored the cross section of the nave, and yet the window remained a window and the rose a rose. For the window-and-rose combination of St.-Nicaise is not, as might be

thought, a simple enlargement of a bipartite bar-tracery window as seen, for the first time, in Reims Cathedral (fig. 36). In such a window the circular element surmounting the openings is not, as is the rose, a centrifugal but a centripetal form: not a wheel, with spokes radiating from a hub, but a roundel with cusps converging from a rim. Hugues Libergier could never have arrived at his solution by merely magnifying a motif already extant; his is a genuine reconciliation of a *videtur quod* with a *sed contra*.[55]

Concerning the problem of organizing the wall beneath the clerestory (unless this wall was elimin-ated by genuine, independently lighted galleries) the Romanesque style had offered, roughly speak-ing, two contrasting solutions, one emphasizing the two-dimensional surface and horizontal continuity, the other depth and vertical articulation. On the one hand, the wall could be enlivened by a contin-

uous band of small, evenly spaced wall arches as in Ste.-Trinité in Caen (fig. 37), St.-Martin-de-Boscherville, Le Mans, and the churches of the Cluny-Autun type; on the other, by a sequence of major arches (mostly two to each bay and subdivided by colonnettes so as to constitute dead windows, so to speak) which open onto the roof space above the side aisles as in Mont-St.-Michel, the narthex of Cluny, Sens (fig. 38), etc.

The genuine triforium, introduced in Noyon about 1170 (fig. 39), is a first synthesis of these two types: it combines horizontal continuity with an emphasis on shadowy depth. But vertical articulation within the bay was entirely suppressed, and this was bound to be felt all the more keenly as the clerestory windows had begun to be divided into two lights. Thus in the choir of St.-Remi at Reims and in Notre-Dame-en-Vaux at Châlons-sur-Marne (fig. 40), a shaft or shafts (two in St.-Remi, one in

75

Châlons) were carried from the lower ledge of the triforium right up into the clerestory, where they serve as frames for the windows, trisecting or bisecting the triforium itself. Such a solution was, however, rejected in Laon (fig. 18) as well as, about the turn of the century, in Chartres (fig. 41) and Soissons. In these first High Gothic churches, where galleries were dropped for good and the two lights of the windows were unified into one bipartite plate-tracery window, the triforium still— or, rather, again—consists of perfectly equal interstices separated by perfectly equal colonnettes; horizontal continuity rules supreme, all the more so because the string courses overlap the wall shafts.

A reaction against this unmitigated horizontalism set in at Reims where the vertical axis of the triforium bays was emphasized by thickening the central colonnettes so that they might correspond to

the mullions above them (fig. 42). This was done so discreetly that the modern visitor is likely to overlook it. But the master's colleagues did perceive the innovation and thought it important: in his sketch of the inner elevation of Reims Cathedral Villard de Honnecourt so enormously exaggerated the slightly stouter proportions of the central colonnette that no one can help noticing it (fig. 43).[56] What had been a mere hint in Reims became an explicit and emphatic statement in Amiens (fig. 44). Here the triforium bay was actually bisected, as had been the case in Châlons-sur-Marne and, at an earlier stage of evolution, in Sens: it was cut apart into two separate units, with the central colonnette transformed into a clustered pier the main shaft of which connects with the central mullion of the window.

However, in doing this, the masters of Amiens almost negated the whole idea of the triforium,

77

dividing as they did each bay into two "blind windows" and transforming the even sequence of colonnettes into an alternation of members different in kind, viz., colonnettes and clustered piers. As though to counteract this overemphasis on vertical articulation, they accelerated the rhythm of the triforium and made it independent of that of the clerestory. Each of the two "blind windows" that constitute a triforium bay is divided into three sections, whereas each of the two lights that constitute a clerestory window is divided into two. The horizontal element is further stressed by the elaboration of the lower string course into a band of floral ornament.

It was left to Pierre de Montereau to say the final *respondeo dicendum*: as in Soissons and Chartres, the triforium of St.-Denis (fig. 45) is a continuous sequence of four equal openings, separated by members of the same species. However—and this is

where Amiens comes in—all of these members are now clustered piers instead of colonnettes, the one in the center somewhat stronger than the others; and all of them are carried up into the quadrupartite window, the central pier by means of three shafts connecting with the primary mullion, the others by means of one shaft connecting with the secondaries. Pierre de Montereau's triforium is not only the first to be glazed but also the first to effect a perfect reconciliation of the *Sic* of Chartres and Soissons (or, if you like, Ste.-Trinité-de-Caen and Autun) with the *Non* of Amiens (or, if you like, Châlons-sur-Marne and Sens). Now, finally, the big wall shafts could be carried over the string courses without fear of disrupting the horizontal continuity of the triforium; and this brings us to the last of our "problems," the conformation of the nave piers.

The earliest genuine *piliers cantonnés* occur, so far as I know, in Chartres Cathedral (begun 1194)

79

where they are, however, not as yet composed of homogeneous elements—a cylindrical core and cylindrical colonnettes—but show, in alternation, a combination of a cylindrical core with octagonal colonnettes and a combination of cylindrical colonnettes with an octagonal core. This latter motif would seem to indicate that the master of Chartres was familiar with a movement, apparently originating in the borderline district between France and the Netherlands, which has left its most important traces in the choir of Canterbury Cathedral. Here William of Sens, *magister operis* from 1174 to 1178, had almost playfully indulged in inventing all kinds of variations on a modish theme enthusiastically received in England but hardly ever utilized in France—the theme of piers in which a core of light-colored masonry is picturesquely contrasted with completely detached and monolithic shafts fashioned of darkest marble.[57] He had produced

what may be called a sample card of fancy pier types, and one of these consisted, like the alternate supports at Chartres, of an octagonal core and cylindrical shafts (fig. 46, third pier from left; fig. 54).

The master of Chartres adopted this idea but developed it in an altogether different spirit. He retransformed the detached, monolithic shafts into engaged colonnettes constructed of ordinary masonry; he substituted in every second pair of piers a cylindrical core for the octagonal one; and, above all, he employed the *pilier cantonné,* not as an interesting variant but as the basic element of the whole system. And all the first master of Reims had to do was to eliminate the charming but not quite logical difference in shape between the colonnettes and the core.

In this perfected form, the *pilier cantonné* is in itself a *Sic et Non* solution in that it shows colonnettes,

81

originally applied only to angular elements (splayings or piers), in combination with a cylindrical nucleus. But as the early type of triforium tended to suppress vertical articulation in favor of horizontal continuity, so did the early type of *pilier cantonné* tend to remain columnar rather than "mural." Like a column, it ended with a capital whereas, in a compound pier, the colonnettes facing the nave were carried through to the springings of the vaults. This created problems which gave rise to a zigzag development similar to that which could be observed in the treatment of the triforium.

First, since Gothic capitals are proportioned to the diameter rather than to the height of their shafts,[58] there came about a combination of one big capital (that of the nucleus) with four small ones (those of the colonnettes) only half as high. Second,

and more important, the three—or even five—wall
shafts rising into the vaults still started afresh above
the capitals as had been the case when the piers
were monocylindrical, and it became imperative
to establish a visible connection between at least
the central wall shaft and what I shall call for short
the "nave colonnette," viz., that colonnette of
the pier which faces the nave and not the side aisle
or the neighboring pier. The master of Chartres
sought to achieve this end by omitting the capital
of the "nave colonnette," which thus continues up
to the base of the central wall shaft (fig. 47 and
55). Far from pursuing the same course, the mas-
ters of Reims reverted to the earlier form,[59] leaving
the "nave colonnette" in possession of its capital,
and concentrated instead on the other problem,
the inequality of the capitals' heights. They solved
it by providing each colonnette with two capitals,

one superimposed upon the other, whose combined heights equalled the height of the pier capital (fig. 48 and 56).[60]

Amiens, on the contrary, reverted to the Chartres type, taking, however, one step farther in the same direction in that not only the capital of the "nave colonnette" but also the base of the central wall shaft was eliminated, so that the "nave colonnette" continues into the central wall shaft itself, not only into its base as in Chartres (fig. 49 and 57). The older piers of Beauvais are generally similar to those of Amiens, but revert to the pre-Amiens tradition in restoring the base to the central wall shaft; and this renewed interruption of vertical coherence is further emphasized by decorative foliage (fig. 58).

Yet, when the choir of Beauvais was built, the Gordian knot had already been cut by Pierre de Montereau's bold revival of the compound pier

which solved all difficulties in that the big pier capital and the single "nave colonnette" no longer existed (fig. 50 and 59). The three tall shafts required by the main vaults could be run from the floor bases to the springings without interruption, cutting right through the capitals of the nave arcades (fig. 22). However, Pierre de Montereau endorsed the *Non* rather than reconciled it with the *Sic*. Wisely subordinating the minor problem of the pier to the major problem of the whole system, he chose to sacrifice the columnar principle rather than to renounce that adequate "representation" of the nave wall by the core of the pier which has been mentioned (fig. 52). In this case, the *respondeo dicendum* was to be spoken by the French-trained master of Cologne who combined the cylindrical, four-shafted *pilier cantonné* of Amiens with the tall, continuous shafts and subsidiary colonnettes of Pierre de Montereau's compound pier.[61]

But he sacrificed thereby the logical correspondence between the nave wall and the supports. Seen in a diagram, the ground plan of the nave wall again arbitrarily intersects that of the core of the pier instead of coinciding with it (fig. 53).

The gentle reader may feel about all this as Dr. Watson felt about the phylogenetic theories of Sherlock Holmes: "It is surely rather fanciful." And he may object that the development here sketched amounts to nothing but a natural evolution after the Hegelian scheme of "thesis, antithesis, and synthesis"—a scheme that might fit other processes (for instance, the development of Quattrocento painting in Florence or even that of individual artists) just as well as it does the progress from Early to High Gothic in the heart of France. However, what distinguishes the development of French Gothic architecture from comparable phenomena is, first, its extraordinary consistency;

second, the fact that the principle, *videtur quod, sed contra, respondeo dicendum*, seems to have been applied with perfect consciousness.

There is one scrap of evidence—well known, to be sure, but not as yet considered in this particular light—which shows that at least some of the French thirteenth-century architects did think and act in strictly Scholastic terms. In Villard de Honnecourt's "Album" there is to be found the ground-plan of an "ideal" chevet which he and another master, Pierre de Corbie, had devised, according to the slightly later inscription, *inter se disputando* (fig. 60).[62] Here, then, we have two High Gothic architects discussing a *quaestio*, and a third one referring to this discussion by the specifically Scholastic term *disputare* instead of *colloqui, deliberare*, or the like. And what is the result of this *disputatio*? A chevet which combines, as it were, all possible *Sics* with all possible *Nons*. It has a double ambu-

87

latory combined with a continuous hemicycle of fully developed chapels, all nearly equal in depth. The groundplan of these chapels is alternately semicircular and—Cistercian fashion—square. And while the square chapels are vaulted separately, as was the usual thing, the semicircular ones are vaulted under one keystone with the adjacent sectors of the outer ambulatory as in Soissons and its derivatives.[63] Here Scholastic dialectics has driven architectural thinking to a point where it almost ceased to be architectural.

Notes

Notes

1. To trace the development of this parallel in modern literature would require a separate study; suffice it to refer to the beautiful pages in Charles R. Morey's *Mediaeval Art*, New York, 1942, pp. 255–267.

2. Cf. W. Koehler, "Byzantine Art in the West," *Dumbarton Oaks Papers*, I, 1941, pp. 85 f.

3. Cf. M. Dvořák, *Idealismus und Naturalismus in der gotischen Skulptur und Malerei*, Munich, 1918 (originally in *Historische Zeitschrift*, 3rd ser., XXIII), *passim;* E. Panofsky, *Deutsche Plastik des elften bis dreizehnten Jahrhunderts*, Munich, 1924, pp. 65 ff. We can easily see that the ecclesiastical authorities found it hard to acquiesce in this new, Aristotelian point of view. As late as 1215 the University of Paris endorsed the resolution of the Synod of Paris of 1210 which had condemned Aristotle's *Metaphysics* and *Naturalia* (and even abridgments thereof) together with such outright heretics as David of Dinant and Amaury de Bène who taught the unity of God with His creation. In 1231 Pope Gregory IX tacitly admitted the *Metaphysics* but reiterated the prohibi-

tion of the *Naturalia* as long as they had not been "censored and expurgated of errors." He even set up a commission for this purpose; but by this time the moment for effective countermeasures had passed.

4. The word *compendium* (originally "a hoard," "a saving") had come to mean "a shortcut" (*compendia montis*) and, still more figuratively, a literary "abridgment" (*compendium docendi*). In the resolutions of 1210 and 1215 mentioned in note 3, the word *summa* is still used in this sense: "Non legantur libri Aristotelis de metaphysica et naturali historia, nec *summa* de iisdem." According to general assumption the first instance of a *Summa Theologiae* in the now current sense is that by Robert de Courzon of 1202 (not as yet published in full). It is, however, probable that the *Summae* by Prévostin and Stephen Langton (likewise active at Paris) precede it by some ten or fifteen years; cf. E. Lesne, *Histoire de la propriété ecclésiastique en France*, V (*Les Ecoles de la fin du VIII^e siècle à la fin du XII^e*) Lille, 1940, especially pp. 249 251, 676.

5. Cf. Robert Grosseteste, Roger Bacon, also William Shyreswood.

6. For Ockham, cf. the recent book by R. Guelluy, *Philosophie et Théologie chez Guillaume d'Ockham*, Louvain, 1947;

Notes

for Nicholas of Autrecourt, J. R. Weinberg, *Nicolaus of Autrecourt, a Study in 14th Century Thought*, Princeton, 1948.

7. Thomas Aquinas, *Summa Theologiae* (hereafter quoted as *S. Th.*), I–II, qu. 49, art. 3, c.

8. M. de Wulf, *History of Mediaeval Philosophy*, 3rd English ed. (E. C. Messenger, tr.), London, II, 1938, p. 9.

9. "Here's where you cut it for me." For the proverbial use of this famous phrase (Nicolas de Briart, reprinted in V. Mortet and P. Deschamps, *Recueil de textes relatifs à l'histoire de l'architecture*, Paris, II, 1929, p. 290), cf. G. P. in: *Romania*, XVIII, 1889, p. 288.

10. *S. Th.*, I, qu. 1, art. 6, c.

11. *Ibidem*, qu. 89, art. 1, c.

12. *Ibidem*, qu. 1, art. 8, ad 2.

13. *Ibidem*, qu. 2, art. 2, c.

14. *Ibidem*, qu. 1, art. 8, c: "Cum enim fides infallibili veritati innitatur, impossibile autem sit de vero demonstrari contrarium, manifestum est probationes quae contra fidem inducuntur, non esse demonstrationes, sed solubilia argumenta." Cf. also the passage quoted in F. Ueberweg,

Notes

Grundriss der Geschichte der Philosophie, 11th ed., Berlin, II, 1928, p. 429.

15. *S. Th.*, qu. 32, art. 1, ad 2 ; qu. 27, art. 1 and 3. As is well known, St. Augustine had already likened the relation between the Three Persons, by way of a *similitudo*, to that between memory, intelligence, and love (*De Trinitate*, XV, 41–42, reprinted in *Patrologia Latina*, vol. 42, col. 1088 ff.).

16. *Ibidem*, qu. 27, art. 1, ad 3, and *passim*, for instance, qu. 15, art. 3, ad 4.

17. This general characterization does not, of course, fully apply to a thinker such as St. Bonaventure, just as a general characterization of the High Gothic style does not fully apply to a monument such as the Cathedral of Bourges. In both cases we are faced with monumental exceptions in which earlier, essentially anti-Scholastic—or, respectively, anti-Gothic—traditions and tendencies are developed within the framework of a High Scholastic—or, respectively, High-Gothic—style. As Augustinian mysticism (as cultivated in the twelfth century) survives in St. Bonaventure, so does the Early Christian concept of a transeptless or nearly transept-less basilica (as exemplified by Sens Cathedral, the contemplated nave of Suger's St.-Denis, Mantes, and Notre-Dame-de-Paris) survive in the Cathedral of Bourges (cf. S. McK.

94

Notes

Crosby, "New Excavations in the Abbey Church of Saint Denis," *Gazette des Beaux-Arts,* 6th ser., XXVI, 1944, pp. 115 ff. and below, pp. 61 ff.). Characteristically, both St. Bonaventure's philosophy and Bourges Cathedral (which may be called an Augustinian church) remained without a following in some of their most significant aspects: even the Franciscans, however critical of Thomism, could not maintain St. Bonaventure's persistence in an anti-Aristotelian attitude; even those architects who did not subscribe to the ideals of Reims and Amiens could not accept the Bourges master's retention of sixpartite vaults.

18. Cf., e.g., A. Dempf, *Die Hauptform mittelalterlicher Weltanschauung; eine geisteswissenschaftliche Studie über die Summa,* Munich and Berlin, 1925.

19. Bonaventure, *In Lib. III Sent.,* dist., 9, art. 1, qu. 2. For Bacon's criticism of such rhetorical devices, cf. below, p. 67.

20. Cf. again below, pp. 67 ff.

21. *S. Th.,* Prologue.

22. Alexander of Hales, apparently the first to introduce this elaborate articulation, divides *partes* into *membra* and *articuli;* Thomas in *S. Th.* divides *partes* into *quaestiones* and

articuli. Commentaries upon the Sentences generally divide the *partes* into *distinctiones,* these being subdivided into *quaestiones* and *articuli.*

23. This First Part, dealing with God and the order of creation, is organized as follows:

I. Essence (qu. 2–26);
 a. Whether God exists (qu. 2);
 1. Whether the proposition of His existence is evident (art. 1);
 2. Whether it is demonstrable (art. 2);
 3. Whether He does exist (art. 3);
 b. How He exists or, rather, does not exist (qu. 3–13);
 1. How He is not (qu. 3–11);
 2. How He is known to us (qu. 12);
 3. How He is named (qu. 13);
 c. His operation (qu. 14–26);
 1. His knowledge (qu. 14–18);
 2. His will (qu. 19–24);
 3. His power (qu. 25–26);
II. Distinction of Persons (qu. 27–43);
 a. Origin or procession (qu. 27);
 b. Relations of origin (qu. 28);
 c. The Persons as such (qu. 29–43);
III. Procession of creatures (qu. 44–end);
 a. Production of creatures (qu. 44–46);

b. Distinction of creatures (qu. 47–102);

c. Government of creatures (qu. 103–end).

24. A characteristic masterpiece of a Scholastic eulogy is a *Collatio* in honor of Charles IV by Pope Clement VI (R. Salomon, *M.G.H., Leges,* IV, 8, pp. 143 ff.), where Charles is parallelized with Solomon under the headings: *Comparatur, Collocatur, Approbatur, Sublimatur,* each heading being subdivided as follows:

A. *Comparatur.* Solomon

 I. in aliquibus *profecit:*

 a. in latriae magnitudine;

 b. in prudentiae certitudine;

 c. in iustitiae rectitudine;

 d. in clementiae dulcedine.

 II. In aliquibus *excessit:*

 a. in sapientiae limpitudine;

 b. in abundantiae plenitudine;

 c. in facundiae amplitudine;

 d. in quietae vitae pulchritudine.

 III. in aliquibus *defecit:*

 a. in luxuriae turpitudine;

 b. in perseverantiae longitudine;

 c. in idolatriae multitudine;

 d. in rei bellicae fortitudine, etc., etc.

Ridewall's mythographical treatise was edited by H. Liebe-

schütz, *Fulgentius Metaforalis (Studien der Bibliothek Warburg,* IV, Leipzig and Berlin, 1926); For the scholastic systematization of Ovid's *Metamorphoses (naturalis, spiritualis, magica, moralis,* and *de re animata in rem inanimatam, de re inanimata in rem inanimatam, de re inanimata in rem animatam, de re animata in rem animatam),* cf. F. Ghisalberti, "Mediaeval Biographies of Ovid," *Journal of the Warburg and Courtauld Institutes,* IX, 1946, pp. 10 ff., especially p. 42.

25. The early manuscripts, editions, and commentaries show perfect awareness of the fact that the first Cantica really begins with Canto 2 (so that it would comprise 33 Canti like the others). In the Trivulziana manuscript of 1337 (L. Rocca, ed., Milan, 1921) as well as in such incunabula as Wendelin of Speyer's Venice edition, we find the following rubrics: "Comincia il canto primo de la prima parte nelaquale fae *proemio a tutta l'opera*" and "Canto secondo dela prima parte nela quale fae *proemio ala prima canticha solamente,* cioè ala prima parte di questo libro solamente." Cf. Jacopo della Lana's Commentary (reprinted in L. Scarabelli's edition of the *Divina Commedia* of 1866, pp. 107 and 118): "In questi due primieri Capitoli . . . fa proemio e mostra sua disposizione. . . . Qui *(scil.,* in Canto 2) segue suo proema pregando la scienzia che lo aiuti a trattare tale poetria, sicome è usanza delli poeti in li principii delli suoi trattati, e li oratori in li principii delle sue arenghe."

Notes

26. T. E. Mommsen (Intr.), *Petrarch, Sonnets and Songs,* New York, 1946, p. xxvii.

27. R. Arnheim, "Gestalt and Art," *Journal of Aesthetics and Art Criticism,* 1943, pp. 71 ff.; *idem,* "Perceptual Abstraction and Art," *Psychological Review,* LIV, 1947, pp. 66 ff., especially p. 79.

28. *S. Th.* I, qu. 5, art. 4, ad 1.

29. Paris, Bibl. Nat., Nouv. Acq. 1359 and London, Brit. Mus., Add. 11662 (cf. M. Prou, "Desseins du XIe siècle et peintures du XIIIe siècle," *Revue de l'Art Chrétien,* XXIII, 1890, pp. 122 ff.; also M. Schild-Bunim, *Space in Mediaeval Painting,* New York, 1940, p. 115).

30. Exceptions: Fécamp (after 1168), having compound piers throughout; the eastern bay of St.-Leu d'Esserent (*ca.* 1190) having an alternating system; St.-Yved-de-Braine (after 1200), having compound piers in the chevet; Longpont, having monocylindrical piers.

31. The experiments in the seventh and ninth pair of nave piers in the Cathedral of Laon had no appreciable effect upon the subsequent development; and the piers of Soissons, cylinders with only one colonnette facing the nave, are in my opinion a reduction of the full-fledged Chartres *pilier cantonné* with colonnettes on all four sides. Perfunctorily imi-

tated in Notre-Dame-de-Paris (second pair of piers from the west), this type is chiefly important for its influence upon provincial structures erected after the middle of the thirteenth century (cf. note 61), and upon the supports in the *rond-point*—and in the *rond-point* only—of Reims and Beauvais Cathedrals. For the development of the *pilier cantonné* see pp. 79 ff.

32. Some architectural historians are inclined to identify the climactic phase of the Gothic style with Reims and Amiens (nave), and to consider the radical elimination of the wall in the nave of St.-Denis, the Sainte-Chapelle, St.-Nicaise-de-Reims, or St.-Urbain-de-Troyes as the beginning of a disintegration or decadence ("*Gothique rayonnant*" as opposed to "*Gothique classique*"). This is, of course, a matter of definition (cf. P. Frankl, "A French Gothic Cathedral: Amiens," *Art in America*, XXXV, 1947, pp. 294 ff.). But it would seem that the Gothic style, measured by its own standards of perfection, only fulfills itself where the wall is reduced to the limit of technical possibilities while, at the same time, a maximum of "inferability" is reached. I even suspect that the above-mentioned view has some purely verbal foundation in that the expressions "classic High Gothic" or "*Gothique classique*" automatically suggest the plastic standards of Greek and Roman, but not Gothic,

Notes

"classicality." In fact the masters of Amiens themselves eagerly adopted the glazed triforium of St.-Denis as soon as they had become familiar with it (transept and chevet).

33. Viollet-le-Duc's interpretation is carried to an extreme in L. Lemaire, "La logique du style Gothique," *Revue néo-scolastique*, XVII, 1910, pp. 234 ff.

34. P. Abraham, *Viollet-le-Duc et le rationalisme mediéval*, Paris, 1935 (cf. the discussion in *Bulletin de l'office international des Instituts d'archéologie et d'histoire de l'art*, II, 1935).

35. E. Gall, *Niederrheinische und normännische Architektur im Zeitalter der Frühgotik*, Berlin, 1915; idem, *Die gotische Baukunst in Frankreich und Deutschland*, I, Leipzig, 1925. Further literature concerning the Pol Abraham controversy is cited in G. Kubler, "A Late Gothic Computation of Rib Vault Thrusts," *Gazette des Beaux-Arts*, 6th ser., XXVI, 1944, pp. 135 ff.; to be added: Pol Abraham, "Archéologie et résistance des matériaux," *La Construction Moderne*, L, 1934–35, pp. 788 ff. (kindly brought to my attention by Prof. M. Schapiro).

36. *Abbot Suger on the Abbey Church of Saint-Denis and Its Art Treasures* (E. Panofsky, ed.), Princeton, 1946, p. 108, 8; for the emendation of *veluti* into *voluti*, see E. Panofsky, "Postlogium Sugerianum," *Art Bulletin*, XXIX, 1947, p. 119.

101

Notes

37. See G. Kubler, *loc. cit.*

38. Cf. E. Brunet, "La restauration de la Cathédrale de Soissons," *Bulletin Monumental*, LXXXVII, 1928, pp. 65 ff.

39. Cf. H. Masson, "Le rationalisme dans l'architecture du Moyen-Age," *Bulletin Monumental*, XCIV, 1935, pp. 29 ff.

40. See, for instance, the treatise convincingly interpreted by Kubler, *loc. cit.*, or the French expert Mignot's violent and justified objections to the outrageous theory of his Milanese confreres according to which "archi spiguti non dant impulzam contrafortibus" (cf. now J. S. Ackerman, " 'Ars Sine Scientia Nihil Est' ; Gothic Theory of Architecture at the Cathedral of Milan," *Art Bulletin*, XXXI, 1949, pp. 84 ff.). As evidenced by the Milan texts (reprinted in Ackerman, *loc. cit.*, pp. 108 ff.), the terms *contrefort* and *arc-boutant* ("archi butanti") were familiar even in Latin and Italian by the end of the fourteenth century, and both were used in a figurative sense as early as in the fifteenth and six-teenth centuries (*Dictionnaire historique de la langue franaçise publié par l'Académie Française*, III, Paris, 1888, pp. 575 ff. ; E. Littré, *Dictionnaire de la langue française*, I, Paris, 1863, p. 185; La Curne de la Palaye, *Dictionnaire historique de l'ancienne langue française*, IV, Paris and Niort, 1877, p. 227). The term *bouterec* (F. Godefroy, *Lexique de l'ancien Français*, Paris, 1901, p. 62) must have been in use before 1388 when

Notes

"buttress" occurs in English, and *estribo* is constantly employed in the treatise interpreted by Kubler, *loc. cit.*

41. Since this upper range of flying buttresses is superfluous as far as the stability of the vaults is concerned, its presence has even been accounted for by mere "timidity" (J. Guadet, *Eléments de théorie d'architecture*, Paris, n.d., III, p. 188). To explain it as a countermeasure against wind pressure was proposed by K. J. Conant, "Observations on the Vaulting Problems of the Period 1088–1211," *Gazette des Beaux-Arts*, 6th ser., XXVI, 1944, pp. 127 f.

42. See E. Gall, *opp. cit.*, especially *Die gotische Baukunst*, pp. 31 ff.

43. See J. Gaudet, *op. cit.*, pp. 200 ff., fig. 1076.

44. G. Vasari, *Le Vite dei più eccellenti pittori, scultori e architetti*, II Part, Proemio: "Perchè nelle colonne non osservarono (*scil.*, the Gothic masters) quella misura e proporzione che richiedeva l'arte, ma a la mescolata con una loro regola senza regola faccendole grosse grosse o sottili sottili, come tornava lor meglio." In thus observing that the scale of the members in a Gothic edifice is not determined by anthropomorphic considerations, and that their proportions can change within one and the same building, Vasari—his acumen sharpened by hostility—has hit upon a fundamental

principle distinguishing Gothic from Classical as well as from Renaissance and Baroque architecture. Cf. C. Neumann, "Die Wahl des Platzes für Michelangelos David in Florenz im Jahr 1504; zur Geschichte des Massstabproblems," *Repertorium für Kunstwissenschaft*, XXXVIII, 1916, pp. 1 ff. Also E. Panofsky, "Das erste Blatt aus dem 'Libro' Giorgio Vasaris; eine Studie über die Beurteilung der Gotik in der italienischen Renaissance," *Städeljahrbuch*, VI, 1929, pp. 4 ff., especially pp. 42 ff.

45. See S. McK. Crosby, *loc. cit.*; for Bourges, cf. above, note 17.

46. Until fairly recently, the first instance of a four-story arrangement was believed to occur in Tournai (*ca.* 1100). Two very slightly earlier though much more primitive instances—again demonstrating the close interrelation between Flanders and England—have, however, been discovered in Tewkesbury (founded in 1087) and Pershore (founded between 1090 and 1100); cf. J. Bony, "Tewkesbury et Pershore, deux élévations à quatre étages de la fin du XI^e siècle," *Bulletin Monumental*, 1937, pp. 281 ff., 503 ff.

47. The addition of secondary side aisles in Cologne Cathedral (otherwise closely following the plan of Amiens Cathedral) represents a sacrifice of the major consideration (in this case, balance between centralistic and longitudinal

tendencies) to the minor one (in this case, conformity of nave and choir) not unlike that which can be observed in the treatment of the supports (cf., pp. 85 ff.).

48. *S. Th.* I, qu. 1, art. 8, ad 2.

49. *Patrologia Latina*, vol. 178, cols. 1339 ff.

50. Roger Bacon, *Opus minus* as quoted in H. Felder, *Geschichte der wissenschaftlichen Studien im Franziskanerorden*, Freiburg, 1904, p. 515: "Quae fiunt in textu principaliter legendo et praedicando, sunt tria principaliter; scilicet, divisiones per membra varia, sicut artistae faciunt, concordantiae violentes, sicut legistae utuntur, et consonantiae rhythmicae, sicut grammatici." For the anticipation of the *Sic et Non* method by the canonists (Ivo of Chartes, Bernold of Constance), see M. Grabmann, *Die Geschichte der scholastischen Methode*, Freiburg, 1909, I, pp. 234 ff.; I and II, *passim*.

51. William of Ockham, *Quodlibeta*, I, qu. 10, as quoted in Ueberweg, *op. cit.*, p. 581: "Quidquid de hoc senserit Aristoteles, non curo, quia ubique dubitative videtur loqui."

52. William of Ockham, *In I sent.*, dist. 27, qu. 3, quoted *ibidem*, pp. 574 f.: "Pauca vidi de dictis illius doctoris. Si enim omnes vices, quibus respexi dicta sua, simul congregarentur, non complerent spatium unius diei naturalis . . .

quam materiam tractavi, et fere omnes alias in primo libro, *antequam vidi opinionem hic recitatam.''*

53. See H. Kunze, *Das Fassadenproblem der französischen Früh- und Hochgotik,* Strassburg, 1912.

54. Germany, generally averse to roses in the west façade (except for Strassburg and its sphere of influence, in contrast to Cologne, etc.), accepted the rose-and-window combination for the longitudinal walls of hall churches when elaborated into façades as in Minden, Oppenheim, St. Catherine's in Brandenburg.

55. Libergier's solution was obviously inspired by the transepts of Reims Cathedral (before 1241), where the big roses are already inscribed within pointed arches; but here the whole does not, as yet, constitute a "window." The spandrels above and below the roses are not, as yet, glazed, and no vertical connection exists between the roses and the windows beneath them.

56. *Villard de Honnecourt, Kritische Gesamtausgabe* (H. R. Hahnloser, ed.), Vienna, 1935, pp. 165 ff., pl. 62.

57. Cf. now J. Bony, "French Influences on the Origins of English Gothic Architecture," *Journal of the Warburg and Courtauld Institutes,* XII, 1949, pp. 1 ff., especially pp. 8 ff.

Notes

58. See, e.g., A. Kingsley Porter, *Medieval Architecture,* New Haven, 1912, II, p. 272. Occasionally, as in St.-Martin-de-Boscherville or St.-Etienne-de-Caen (galleries), this principle had already been applied in Romanesque structures; but it became "standard," it seems, only after Sens, where three different thicknesses are "expressed" by capitals of three different sizes. There was, however, always an inclination to overlook minor differences in thickness in order to preserve uniformity among several adjacent capitals.

59. In Soissons, St.-Leu-d'Esserent, etc., we find an even more emphatic reversion to the original Canterbury type: a "nave colonnette" with an individual capital half as high as that of the pier.

60. This applies also to the capitals of the major and minor colonnettes of the west portals which thus form a significant contrast to the corresponding ones in Amiens.

61. A similar adaptation of a continuous shaft to the concept of a *pilier cantonné* can be observed in the later piers of Beauvais (1284 ff.), in the piers of Séez (*ca.* 1260) and in the later piers of Huy (1311 ff.). In the two latter instances, however, the colonnettes facing the arcades and the side aisles are omitted as though the idea of a continuous shaft had been superimposed, not upon the normal *pilier cantonné*

(with four colonnettes) but upon the Soissons pier (which has only one); cf. note 31.

62. Villard de Honnecourt, *op. cit.,* pp. 69 ff., pl. 29; the inscription, "Istud bresbiterium inuenerunt Ulardus de Hunecort et Petrus de Corbeia inter se disputando," was added by a disciple of Villard known as "Master 2."

63. The only superficially similar alternation of chapels vaulted separately and chapels vaulted, Soissons fashion, under one keystone with the adjacent sector of the outer ambulatory can be observed in Chartres, where this arrangement is motivated by the necessity of re-using the foundations of the eleventh-century choir with its three deep and widely separated chapels. But in Chartres the Soissons-like chapels are really nothing but shallow protuberances of the outer ambulatory, so that all the seven keystones could be placed on the same perimeter. In Villard de Honnecourt's and Pierre de Corbie's ideal plan they are fully developed units, their keystones placed, not in the center but on the periphery of the adjacent sector of the outer ambulatory.

Illustrations

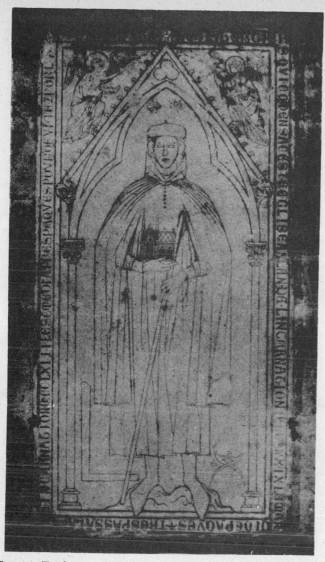

Figure 1. Tombstone of the Architect Hugues Libergier (died 1263), Reims Cathedral.

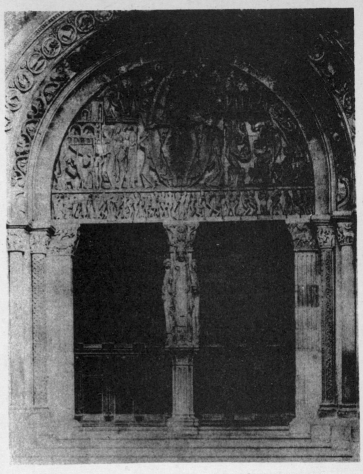

Figure 2. Autun Cathedral, west portal. *Ca.* 1130.

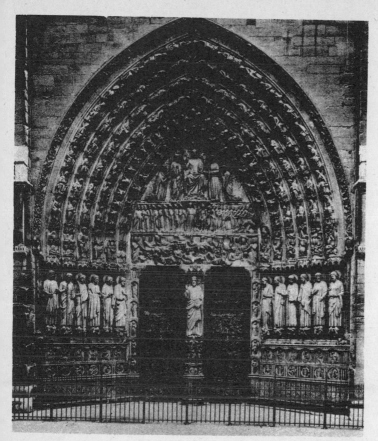

Figure 3. Paris, Notre-Dame, central portal of the west façade (much restored). *Ca.* 1215–1220.

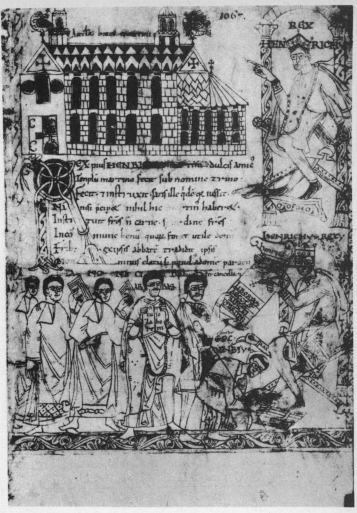

Figure 4. Henry I of France bestowing privileges upon the Priory of St.-Martin-des-Champs. Book illumination between 1079 and 1096, London, British Museum, ms. Add. 1162, fol. 4.

114

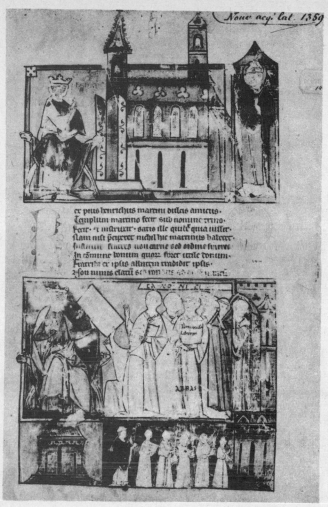

Figure 5. Henry I of France bestowing privileges upon the Priory of St. Martin des Champs. Book illumination of *ca.* 1250, Paris, Bibliothèque Nationale, ms. Nouv. Acq. lat. 1359, fol. 1.

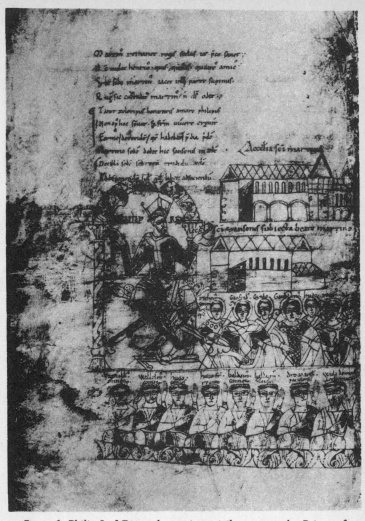

Figure 6. Philip I of France bestowing privileges upon the Priory of
St.-Martin-des-Champs. Book illumination between 1079 and 1096,
London, British Museum, ms. Add. 1162, fol. 5 v.

Figure 7. Philip I of France bestowing privileges upon the Priory of St.-Martin-des-Champs. Book illumination of *ca.* 1250, Paris, Bibliothèque Nationale, ms. Nouv. Acq. lat. 1359, fol. 6.

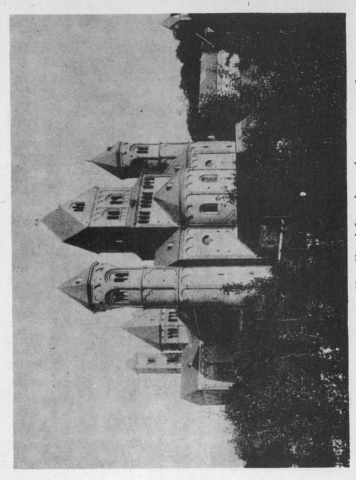

Figure 8. Maria Laach, Abbey Church from the northwest. 1093–1156.

118

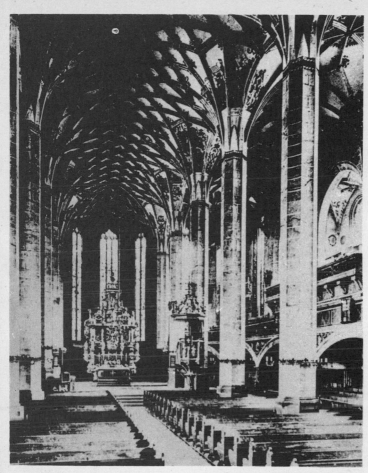

Figure 9. Pirna (Saxony), Marienkirche, interior. Begun 1502.

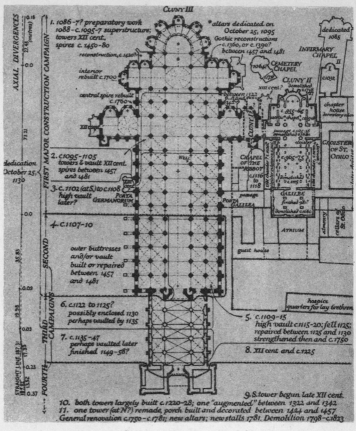

Figure 10. Cluny, Third Abbey Church, groundplan, 1088–*ca.* 1120; narthex *ca.* 1120–*ca.* 1150. (After K. J. Conant, "The Third Church of Cluny," *Medieval Studies in Memory of A. Kingsley Porter*, Cambridge, 1939.)

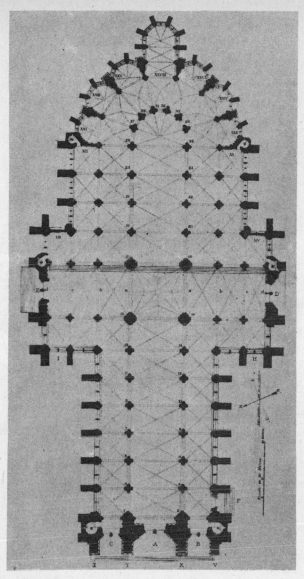

Figure 11. Amiens Cathedral, groundplan. Begun 1220.

121

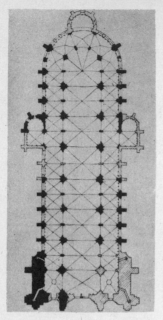

Figure 12. Sens Cathedral, groundplan.
Constructed *ca.* 1140–*ca.* 1168. (After
E. Gall, *Die gotische Baukunst in
Frankreich und Deutschland,*
Leipzig, 1925.)

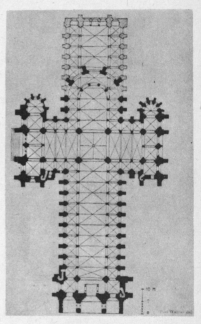

Figure 13. Laon Cathedral, groundplan.
Begun *ca.* 1160.

122

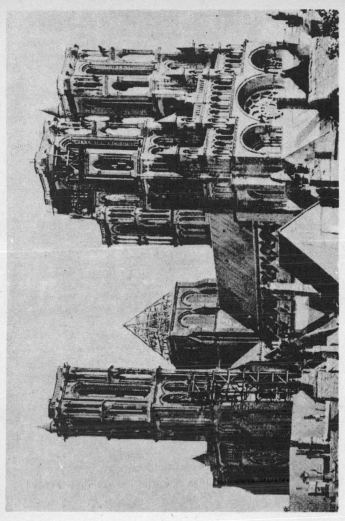

Figure 14. Laon Cathedral from the northwest. Begun *ca.* 1160.

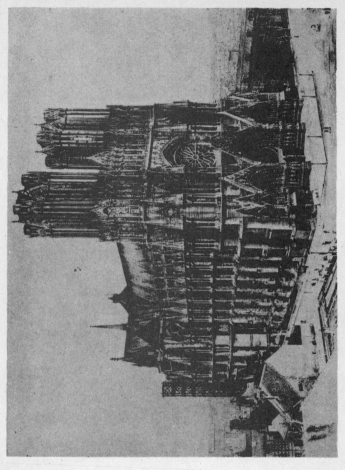

Figure 15. Reims Cathedral from the northwest. Begun 1211.

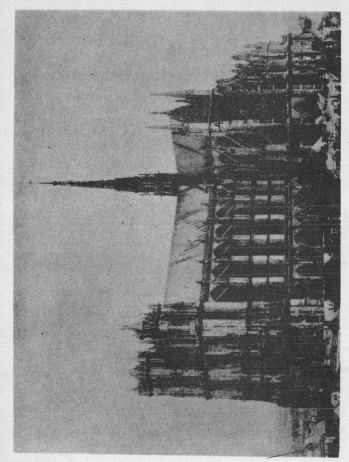

Figure 16. Amiens Cathedral from the northeast. Begun 1220.

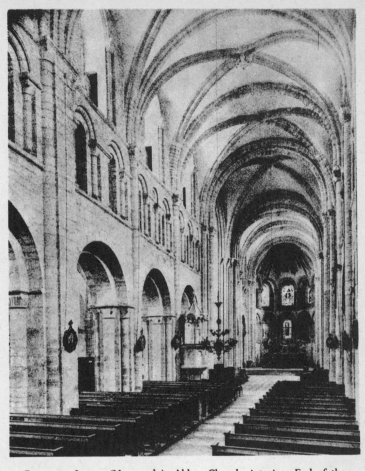

Figure 17. Lessay (Normandy), Abbey Church, interior. End of the
XIth century.

126

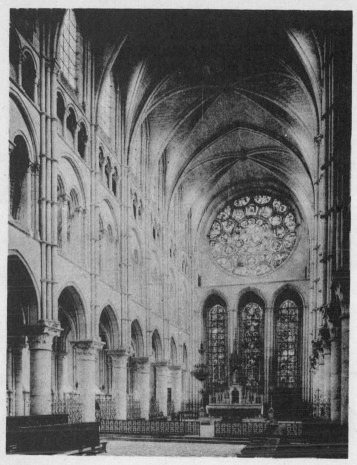

Figure 18. Laon Cathedral, interior of the choir. Begun after 1205 in conformity with elevation designed *ca.* 1160.

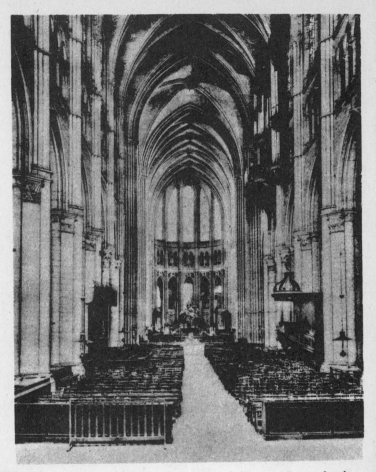

Figure 19. Chartres Cathedral, interior of the nave. Begun shortly
after 1194.

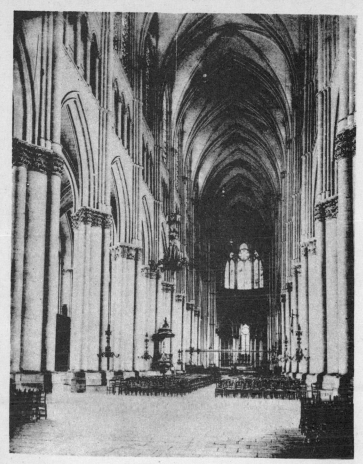

Figure 20. Reims Cathedral, interior of the nave. Begun 1211.

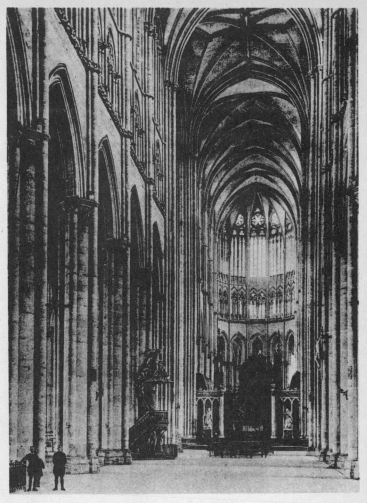

Figure 21. Amiens Cathedral, interior of the nave. Begun 1220.

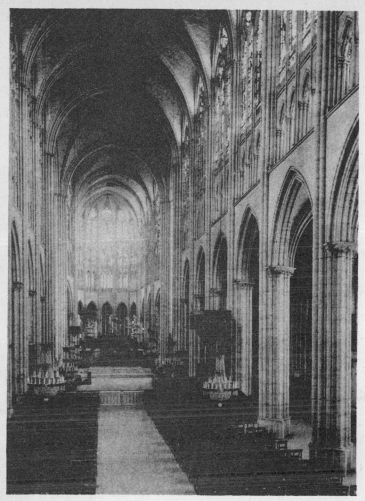

Figure 22. St.-Denis, interior of the nave. Begun 1231.

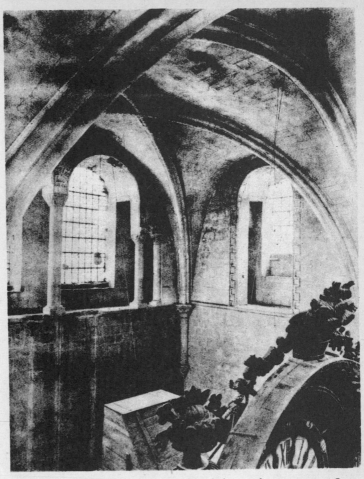

Figure 23. Caen, St.-Etienne, vaults of the northern transept. *Ca.*
1110. (After E. Gall, *op. cit.*)

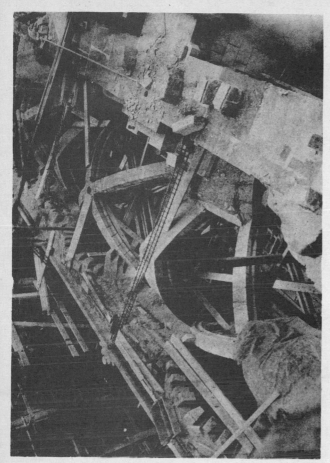

Figure 24. Soissons Cathedral, vaults of the southern side aisle in course of restoration after World War I. Beginning of the XIIIth century.

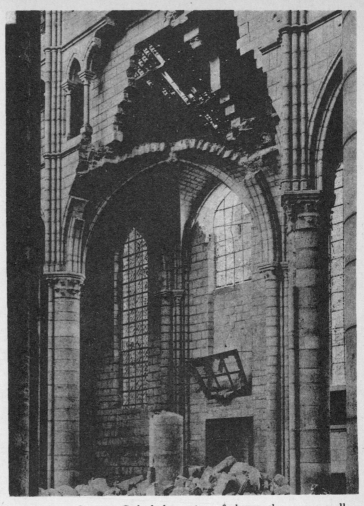

Figure 25. Soissons Cathedral, section of the northern nave wall damaged during World War I. Beginning of the XIIIth century.

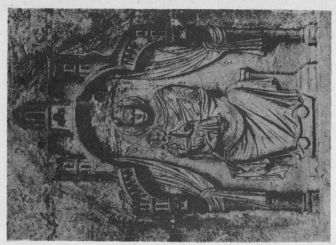

Figure 27. Reims Cathedral, Madonna in the right-hand portal of the northern transept. *Ca.* 1211-1212.

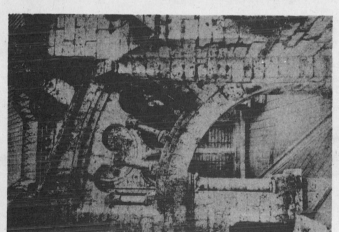

Figure 26. Chartres Cathedral, fly:ng buttress of the nave. Design established shortly after 1194.

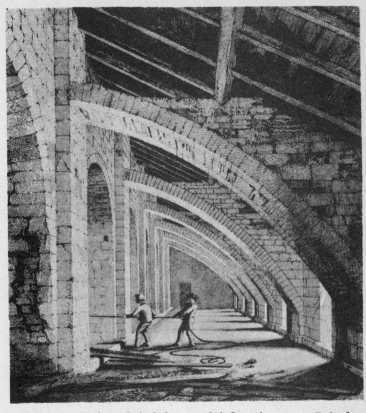

Figure 28. Durham Cathedral, concealed flying buttresses. End of the XIth century. (After R. W. Billings, *Architectural Illustrations and Description of the Cathedral of Durham*, London, 1843.)

136

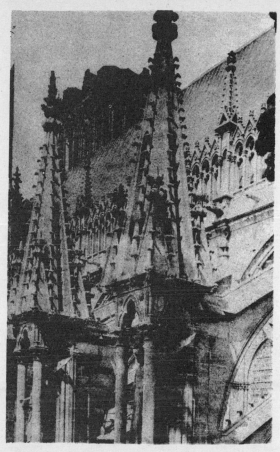

Figure 29. Reims Cathedral, open flying buttresses of the nave. Design established *ca.* 1211.

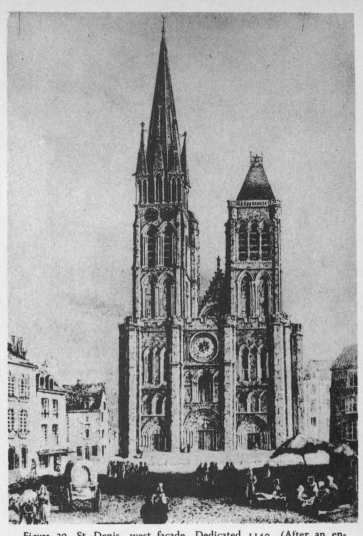

Figure 30. St.-Denis, west façade. Dedicated 1140. (After an engraving by A. and E. Rouargue, executed before the restoration of 1833–1837.)

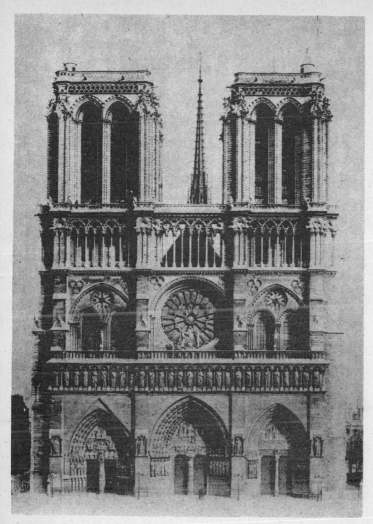

Figure 31. Paris, Notre-Dame, west façade. Begun shortly after 1200;
clerestory *ca.* 1220.

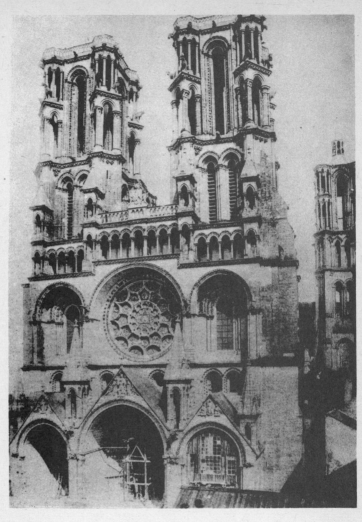

Figure 32. Laon Cathedral, west façade. Designed *ca.* 1160; executed from *ca.* 1190.

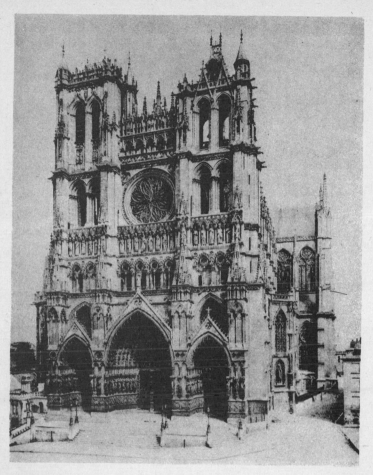

Figure 33. Amiens, west façade. Begun 1220; clerestory completed
1236; tracery of the rose *ca.* 1500.

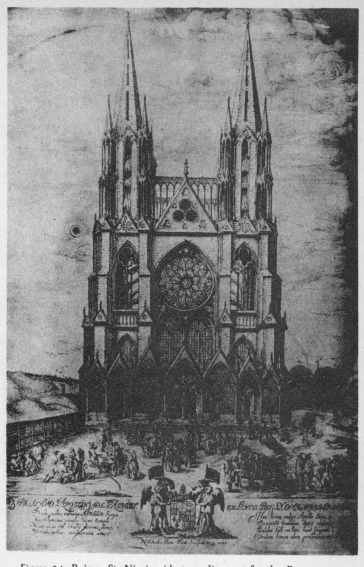

Figure 34. Reims, St.-Nicaise (destroyed), west façade. Between *ca.* 1230 and 1263; rose restored *ca.* 1550. (After an engraving by N. de Son, of 1625.)

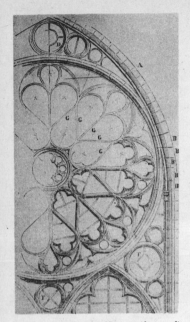

Figure 35. Reims, St.-Nicaise (destroyed), rose in the west façade (partial reconstruction).

Figure 36. Reims Cathedral, nave window. Designed *ca.* 1211.

143

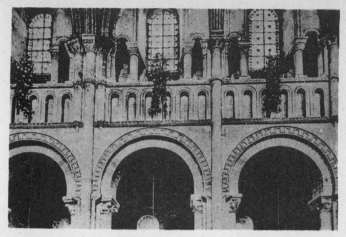

Figure 37. Caen, St.-Trinité, triforium. *Ca.* 1110.

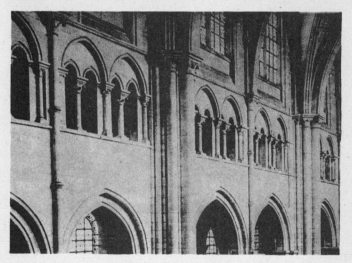

Figure 38. Sens Cathedral, triforium galleries. Towards 1150.

144

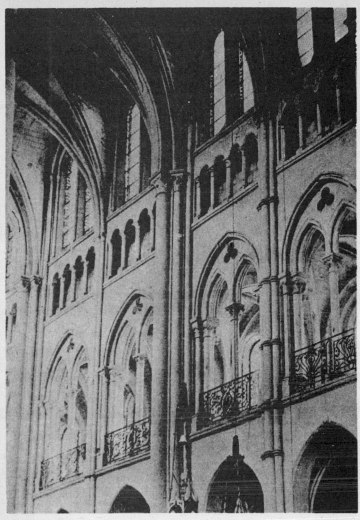

Figure 39. Noyon Cathedral, nave galleries and triforium. Design established *ca.* 1170; eastern bay executed between 1170 and 1185, rest later.

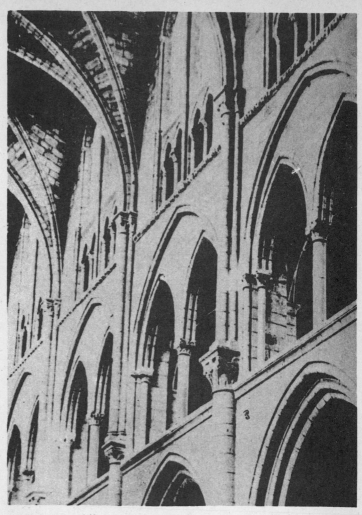

Figure 40. Châlons-sur-Marne, Notre-Dame-en-Vaux, choir galleries and triforium. *Ca.* 1185.

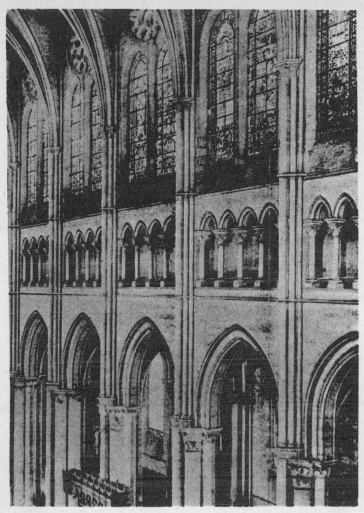

Figure 41. Chartres Cathedral, nave triforium. Design established *ca.* 1194.

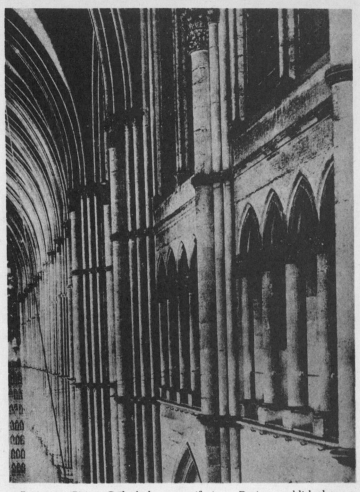

Figure 42. Reims Cathedral, nave triforium. Design established *ca.*
1211.

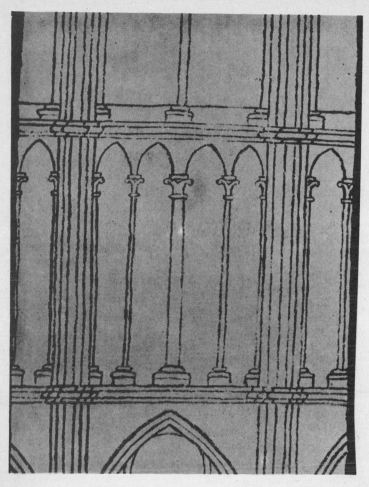

Figure 43. Villard de Honnecourt, interior elevation of Reims Ca-
thedral. Drawing of *ca.* 1235, Paris, Bibliothèque Nationale (en-
larged detail).

149

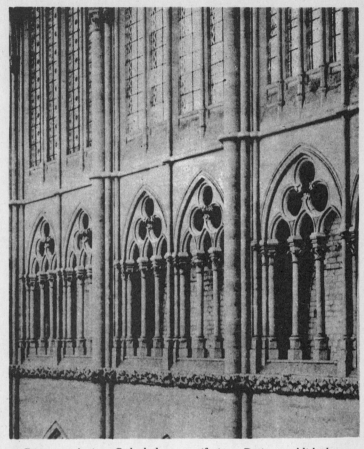

Figure 44. Amiens Cathedral, nave triforium. Design established *ca.* 1220.

150

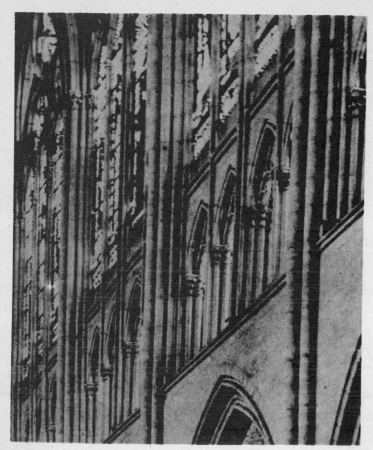

Figure 45. St.-Denis, nave triforium. Design established *ca.* 1231.

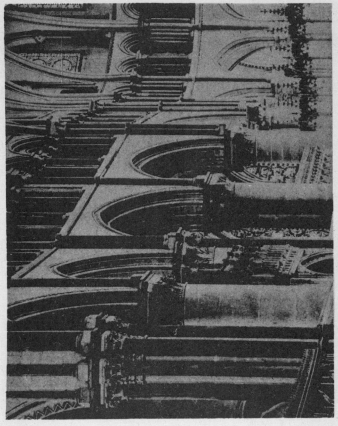

Figure 46. Canterbury Cathedral, choir piers. 1174–1178.

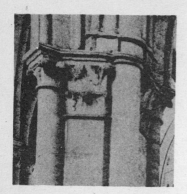

Figure 47. Chartres Cathedral, capital of nave pier. Design established *ca.* 1194.

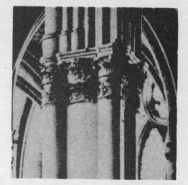

Figure 48. Reims Cathedral, capital of nave pier. Design established *ca.* 1211.

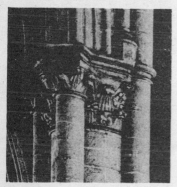

Figure 49. Amiens Cathedral, capital of nave pier. Design established *ca.* 1220.

Figure 50. St.-Denis, capital of **nave** pier. Design established *ca.* 1231.

Figure 51. Amiens Cathedral, cross section of pier in relation to wall and vault-ribs. Design established ca. 1220.

Figure 52. St.-Denis, cross section of pier in relation to wall and vault-ribs. Design established ca. 1231.

Figure 53. Cologne Cathedral, cross section of pier in relation to wall and vault-ribs. Design established ca. 1248.

154

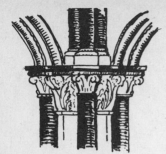

Figure 54. Canterbury Cathedral, capital of pier. 1174–1178 (diagram).

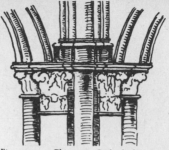

Figure 55. Chartres Cathedral, capital of pier. Design established shortly after 1194 (diagram).

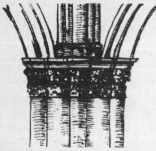

Figure 56. Reims Cathedral, capital of pier. Design established *ca.* 1211 (diagram).

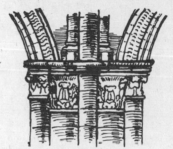

Figure 57. Amiens Cathedral, capital of pier. Design established *ca.* 1220 (diagram).

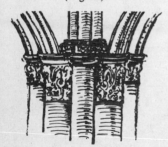

Figure 58. Beauvais Cathedral, capital of pier. Design established *ca.* 1247 (diagram).

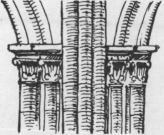

Figure 59. St.-Denis, capital of pier. Design established *ca.* 1231 (diagram).

155

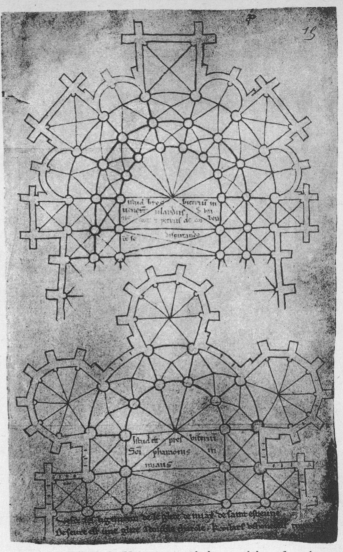

Figure 60. Villard de Honnecourt, ideal groundplan of a chevet resulting from his discussion with Pierre de Corbie. Drawing of *ca.* 1235, Paris, Bibliothèque Nationale.

ERWIN PANOFSKY

Erwin Panofsky was born in Germany in 1892. Educated at Berlin, Munich, and Freiburg universities, he became a lecturer in the history of art at Hamburg University in 1921. He was a professor there from 1926 until 1933. From 1931 to 1933 he was also a visiting professor at New York University. In 1934 he was a visiting lecturer at Princeton University, where he worked as a professor at the Institute for Advanced Study from 1935 until his death. He was Charles Eliot Norton Professor of Poetry at Harvard University during 1947-48. Among his other works in English are *Studies in Iconology* (1939), *The Codex Huyghens and Leonardo da Vinci's Art Theory* (1940), *Albrecht Durer* (first edition, 1943), *Abbot Suger on the Abbey Church of St. Denis and Its Art Treasures* (1946), *Early Netherlandish Painting: Its Origin and Character* (1953), and *Galileo as a Critic of the Visual Arts* (1954).

There's an epidemic with 27 million victims. And no visible symptoms.

It's an epidemic of people who can't read.

Believe it or not, 27 million Americans are functionally illiterate, about one adult in five.

The solution to this problem is you... when you join the fight against illiteracy. So call the Coalition for Literacy at toll-free **1-800-228-8813** and volunteer.

Volunteer Against Illiteracy. The only degree you need is a degree of caring.